THROUGH THE EYES OF
VINCENT VAN GOGH

THROUGH THE EYES OF
VINCENT VAN GOGH

REVEALING THE GENIUS OF THE GREAT MASTER

BARRINGTON BARBER

ARCTURUS

With thanks to Charlotte Gerlings

ISBN 978-1-4351-5856-6
AD004447UK

Manufactured in China

2 4 6 8 10 9 7 5 3 1

CONTENTS

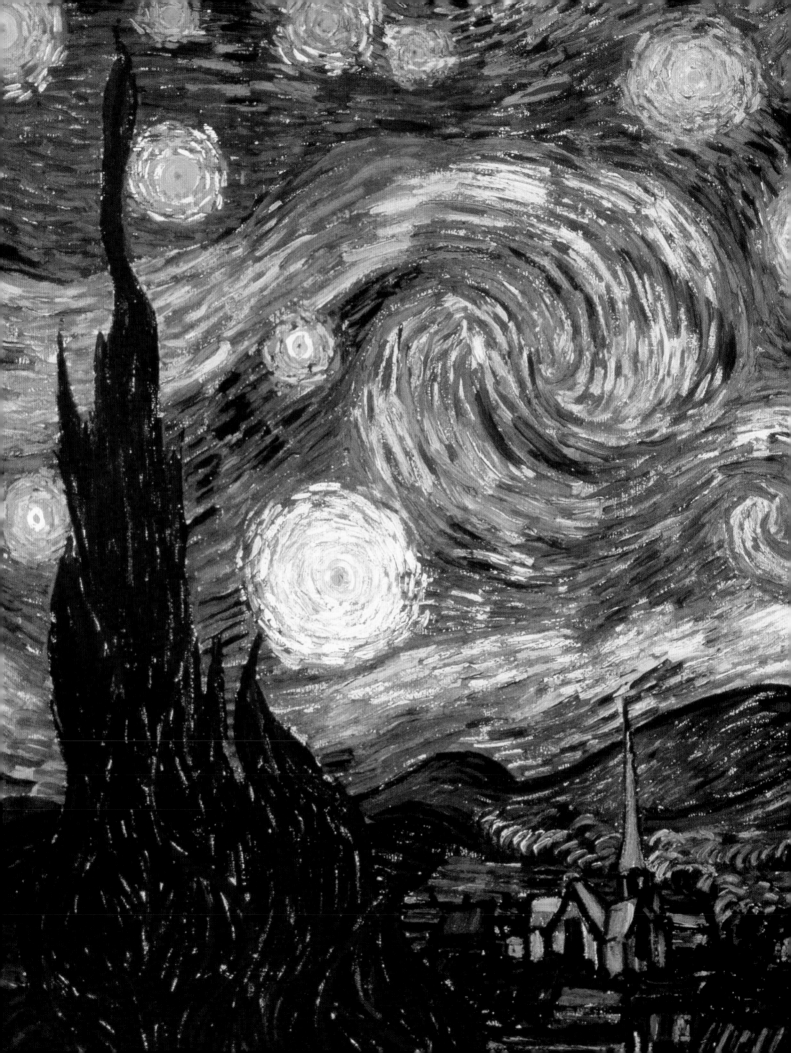

INTRODUCTION

One of the most potent names in art, Vincent van Gogh takes his place in the roll-call of famous artists such as Leonardo da Vinci and Pablo Picasso. Sunflowers, starry nights, a severed ear and suicide: he is an irresistible example of tortured genius.

Vincent Willem van Gogh was born on 30 March 1853 in Groot-Zundert, in the Brabant region of the Netherlands. He was one of seven children born to Theodorus van Gogh (1822–85), a Dutch Reformed Church pastor, and Anna Cornelia Carbentus (1819–1907), the daughter of a bookbinder.

Two brothers and three sisters followed; all survived, an older sibling having died. Theodorus (Theo), Van Gogh's favourite and closest friend, was four years his junior. Of his sisters, Van Gogh loved Willemina (Wil) best, although the age gap was nine years. The young Vincent was 'intensely serious and uncommunicative, and walked around clumsily, in a daze with his head hung low'. Van Gogh himself admitted to a rather sombre childhood, although he loved roaming the fields, heathland and pine forests around their home.

Despite his awkwardness he was a clever student, and in July 1869 he travelled to The Hague to become a junior clerk at Goupil and Company, art dealers with branches in London, Paris and Brussels. His Uncle Vincent was a share-holding partner in the firm and helped to secure him the position. Goupil exhibited and dealt in 18th- and 19th-century art, as well as reproductions of the old masters. The young Van Gogh was quick to observe the

styles of various painters, at the same time learning to value their work from a dealer's point of view. However, the commercial aspect bothered him; he complained to his sister Wil that only 'one-tenth of all business that is transacted is really done out of belief in the art'.

In May 1873, Van Gogh came to England on a two-year transfer to Goupil's London branch. Their stock consisted mostly of prints and photographic reproductions, but consignments of paintings soon began to arrive for Van Gogh's attention.

Van Gogh went to the London galleries when he could. Although unfamiliar with English painting, he particularly liked Constable and had some regard for Turner, Reynolds, Gainsborough and Bonington, and the contemporary artists Millais and Boughton.

In late August, Van Gogh found lodgings at 87 Hackford Road, Brixton. His landlady, Ursula Loyer, ran a small school on the premises with her daughter Eugenie.

Around this time, Theo announced that he was to join Goupil at The Hague branch. Van Gogh's first letter to him of 1874 contained a long list of recommended artists; he had become particularly keen on the realism of Millet's peasant pictures, and also Breton, Corot and Mauve.

Yet deep down he was not happy, and that summer his parents found him 'thin, silent, dejected – a different being'. Van Gogh had recently taken up drawing in England and filled much of his holiday – and a small sketchbook – with landscapes.

Goupil's clients shrank from the forthright opinions of the young Dutchman, who would pass unsolicited judgement on their choices. So Van Gogh was removed

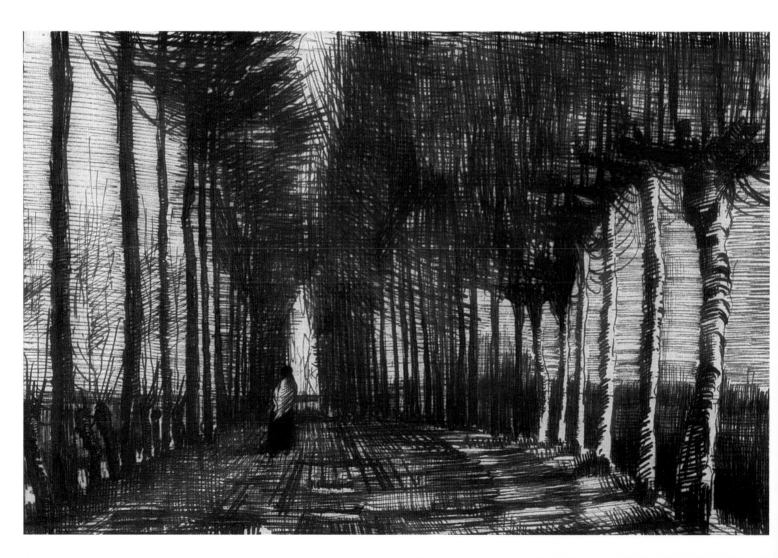

to the Paris branch for the last three months of 1874, and Christmas was spent with the family at his father's parsonage in Helvoirt.

He went back to London in the new year and, although he had behaved outrageously – telling Goupil that their trade was no better than organized theft – they granted him another chance in Paris, thanks once more to the influence of Uncle Vincent.

However, after Christmas 1875, spent at his father's new parsonage in Etten, Van Gogh was summoned to the Paris office and informed that his employment would end on 1 April 1876.

Theo suggested he might start again and study painting. However, Van Gogh revealed that he was going *au pair* as a teacher at a boarding school in Ramsgate, England.

While there, Van Gogh sent an enterprising letter to a clergyman whose church he had attended in London. The letter stressed his experience of travelling among different people, as well as his 'innate love of the church'.

By July 1876, Van Gogh had moved to Isleworth, a village west of London, and to the home of the Reverend Thomas Slade-Jones. For board, lodging and a modest salary, Van Gogh would combine teaching a few boys with assisting the Methodist minister. Throughout the autumn term, the Reverend Jones allowed Van Gogh to speak at prayer meetings.

But despite modelling himself on his father, Van Gogh proved not to be an impressive preacher and by December 1876 his career in England was over. In Etten that Christmas, Theodorus declared that Van Gogh couldn't hope to advance his vocation without attending theological college.

In May 1877, Van Gogh went to lodge in Amsterdam with another uncle (Jan), to study for the university entrance exams and the theological degree necessary

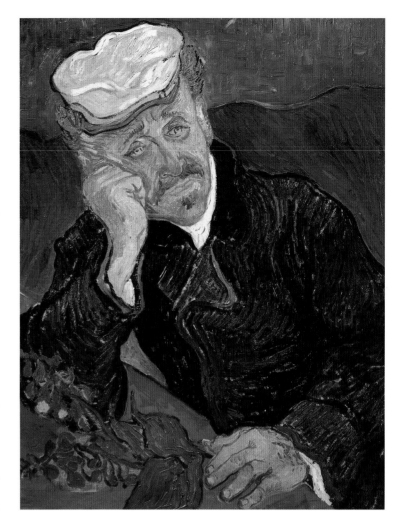

for a good position in the Church. Latin, Greek and mathematics were on the curriculum and Van Gogh pursued them for over a year ('the worst time of my life') before dropping out in July 1878.

Van Gogh next tried Laeken, near Brussels, and a short course at the School of Evangelism. Theodorus had recommended this, hoping that it would suit him better, but again Van Gogh failed to qualify. His next move was to Paturages near Mons, in the grim mining district of Belgium called the Borinage. Happily, Van Gogh was appointed a lay preacher for six months at Wasmes. He threw himself into the work but, typically, went too far. He slept on straw, gave all his warm clothes away and ate leftovers. The mission sponsors were disgusted at his appearance and refused to renew his appointment. And so Van Gogh was left virtually destitute in nearby Cuesmes.

He began to sketch the working people around him,

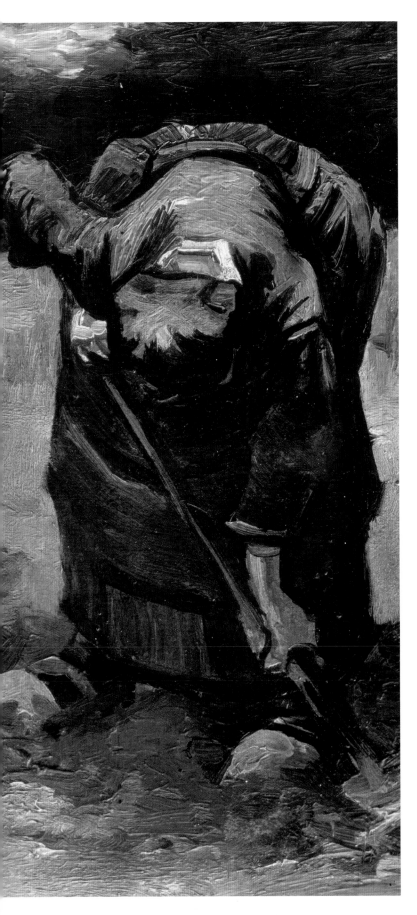

sometimes managing to exchange a drawing for a piece of bread. One generous miner gave him shelter in his crowded cottage and Van Gogh worked outdoors on large sheets of paper for lack of space inside.

He finally contacted Theo, who responded with financial help (which he was to provide for the rest of Van Gogh's life), and in October 1880 Van Gogh moved to a small hotel in Brussels, on the Boulevard du Midi. He looked forward to attending exhibitions again, but above all he longed to meet other artists.

In April 1881, to economize, Van Gogh went back to Etten and his parents. Another visitor to Etten that year was Cornelia Vos-Stricker, nicknamed Kee. She was the daughter of his mother's brother, recently widowed with a young son. Van Gogh fell deeply in love and was devastated when she rejected his offer to replicate her happy marriage. His letters unanswered, he decided to confront Kee at her parents' home in Amsterdam. Uncle Stricker barred the way and Van Gogh held his hand over an oil lamp, threatening to keep it there until Kee appeared. His uncle simply replied by blowing the lamp out and Van Gogh left, humiliated.

Not surprisingly, relations between Van Gogh and his parents worsened. In December, after a violent row with his father, he left for The Hague. There, he contacted the artist Anton Mauve, a cousin by marriage. Mauve supplied Van Gogh with his first set of watercolours and showed him how to use them. With money borrowed from Mauve, Van Gogh was able to set up a small studio of his own, near the railway station, and to employ models.

And so Clasina Hoornik (Sien) entered his life. She was a prostitute and pregnant with her second child. Against all advice, Van Gogh invited her to live with him. To him this seemed idyllic; he had a little family to care for, as well as access to a live model. But Sien also brought health and money problems and Van Gogh's friends did not want to become involved in any of their troubles.

Nevertheless, during nineteen months spent with her and the children, Van Gogh gained his first drawing commissions, produced a number of paintings and tried stone lithography. But life with Sien was always disordered and in the end Van Gogh left. After six lonely weeks in Drenthe, he joined his parents at their new parsonage in December 1883.

Nuenen, near Eindhoven, was populated with craft weavers and spinners, and for the next two years Van Gogh drew and painted in the genre of Millet and Breton, recording peasant life before the arrival of industrialization. He even gave a few art lessons to three pupils in Eindhoven, where he also had the opportunity to continue with his lithography. There was some tension when Van Gogh accused Theo of not trying hard enough to sell the paintings that he had begun supplying. Gently,

Theo pointed out that they were too sombre for current Parisian taste.

Theodorus Senior died from a stroke in March 1885, heralding yet more changes. It happened just as Van Gogh was completing his first large-scale composition, *The Potato Eaters* (p.24), also rated his first masterpiece. Critics complained of rough brushwork and distorted figures but Theo was wiser: 'Wait and see if he has genius. I think he has . . . If he succeeds in his work, he will be a great man . . . Those who care whether there is something in the artist more than mere superficial brilliance will respect him . . . that will be sufficient revenge for the animosity of so many others.'

In January 1886, Van Gogh travelled to Antwerp and enrolled in a fine art course at the Academy. True to nature, he did not last long, but Antwerp did open his

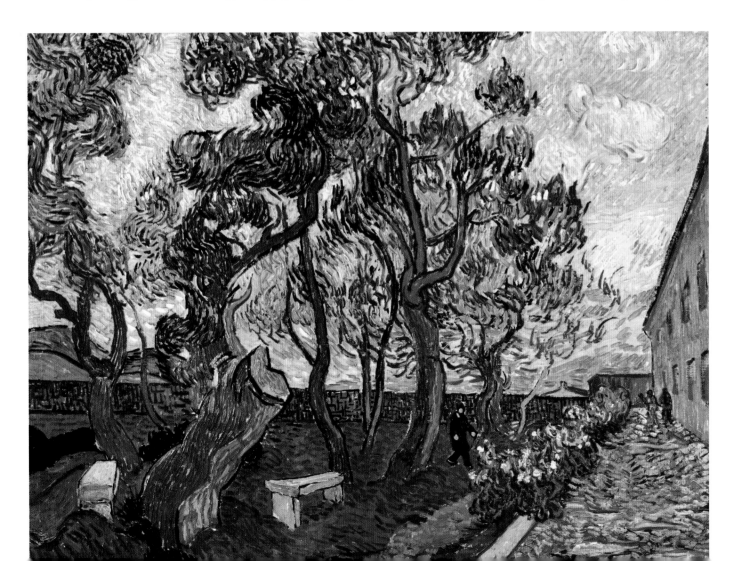

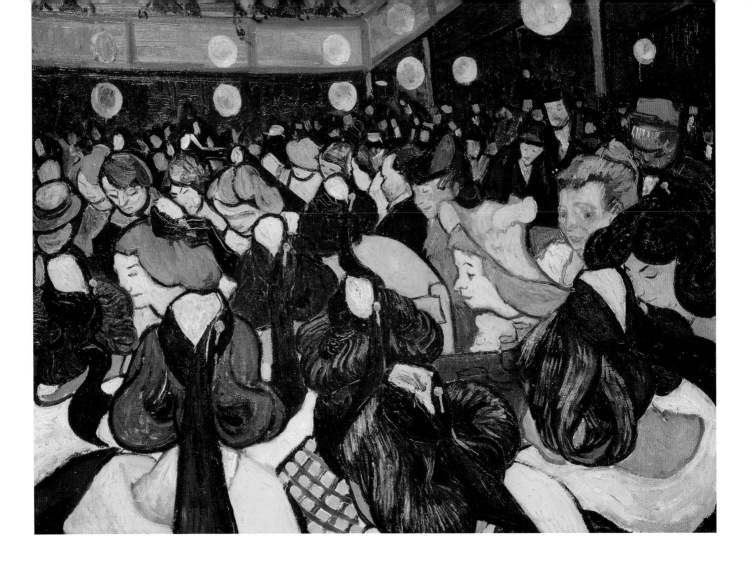

mind to grand architecture, Rubens and Manet, and gave him a taste for the Japanese prints that were all the rage in Paris when he joined Theo there in March.

Theo was managing the Paris branch of Goupil's successors, Boussod, Valadon and Company. His brother's contacts in the Paris art world opened fresh doors for Van Gogh. He met the Pissarros, Monet, Degas, Renoir and Sisley and regularly called in to Père Tanguy's shop in Rue Clauzel – the unofficial headquarters of the avant-garde – where he met Emile Bernard, who was to prove a lasting friend. In May 1886, Van Gogh visited the eighth Impressionist exhibition where he saw works by Gauguin, Seurat and Signac for the first time.

That summer, the brothers moved to a bigger apartment, where Van Gogh could have his own studio. Everyone noticed the difference in him; his health had improved enormously, and his palette became lighter as he experimented with bright colours, painting the fresh flowers he had delivered to the studio every day. He wrote to Wil: 'What is required in art nowadays is something very much alive, very strong in colour, very much intensified.'

Harmony between Theo and Van Gogh wore thin as time went on. Theo was not well (he suffered from syphilis) and living with the unpredictable Van Gogh was exhausting. Throughout 1887, Van Gogh's style continued to develop. He took to working outdoors along the Seine with Bernard and Signac for company and also produced many still lifes and portraits. However, his psychological health was deteriorating, not helped by the fact that he ate hardly anything and drank far too many absinthes and brandies.

In the dark city winter of 1887, Van Gogh became romantically entangled with the female owner of the local Café du Tambourin, where his works were shown alongside post-Impressionists such as Gauguin, Toulouse-

Lautrec and Bernard. Under pressure to make sales to a bourgeois clientele, and unable to cope with his own mood swings, he dreamed of escaping to form an artists' colony somewhere warm. He decided to quit Paris at last and prepare this 'Studio of the South'. Full of optimism for the future, in February 1888 he boarded a train for Arles.

His love of nature revived in sunny Provence and the year yielded more than one hundred paintings. He painted outdoors: landscapes, a series of blossom orchards, lush parks and gardens, and sun-drenched wheatfields at harvest time. He identified each season and subject with specific colours: 'Working directly on the spot all the time, I tried to grasp what is essential.'

He befriended several residents of Arles and some of them sat for their portraits. Van Gogh had reached a peak: 'I am not conscious of myself any more . . . the picture comes to me as in a dream . . . Life is almost enchanted after all.'

He was too busy to be lonely, but he had rented the famous 'Yellow House' and longed to share it with another artist. Summer passed, autumn arrived and then, out of the blue, Gauguin wrote from Brittany. He could not afford the move to Arles but Van Gogh asked Theo to sponsor him.

Theo agreed because Gauguin had shown signs of success on the art market and he hoped that anything he received from the artist in exchange for his support would turn a profit. Excited at Gauguin's coming, Van Gogh painted studies of sunflowers for the walls of his room. They represented the southern sun and when Gauguin saw them he called them 'completely Vincent'.

Gauguin arrived in October 1888 and for nine weeks he and Van Gogh worked together peaceably. Van Gogh painted symbolic portraits of the two of them as chairs, and Gauguin persuaded him to experiment with working from memory. Gauguin painted a portrait of him, which

Van Gogh declared was 'me gone mad'. Unfortunately, this was prophetic.

Van Gogh usually succumbed to depression at the darkest time of the year. That winter, however, a worse illness appeared, a kind of epilepsy, with strange fits during which he might eat paint or even dirt. Just before Christmas, Van Gogh threatened Gauguin with a razor and later cut off his own earlobe. He presented it to one of the prostitutes in a local brothel, asking her to 'keep this object carefully'. Van Gogh was taken to the local hospital. Theo visited him there, but Gauguin disappeared to Paris.

On his discharge in January 1889, Van Gogh was still unwell. He blamed excessive drink and smoking, without giving up either. Petitioned by the anxious people of Arles, he was readmitted to hospital but eventually left

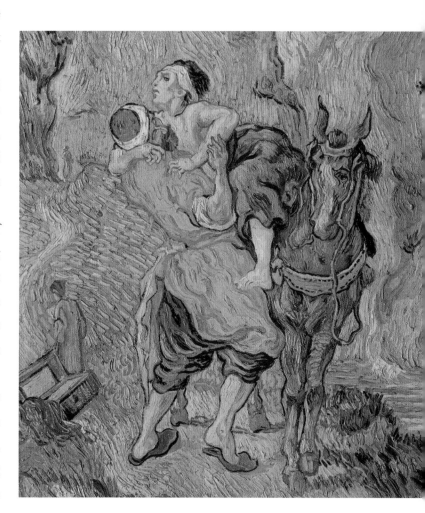

the area in May and headed for St-Rémy, entering the asylum there as a voluntary patient. The diagnosis was 'acute mania with hallucinations of sight and hearing'.

Van Gogh remained in St-Rémy for a year. He had his own room and adapted the one next door as a studio. Apart from some truly debilitating attacks, which resulted in the confiscation of his paints in order to prevent him from poisoning himself, he managed to complete more than 140 pictures: 'I feel happier here with my work than I could be outside. By staying here a good long time . . . the result will be more order in my life.'

At first, he recorded the view from his window. Later

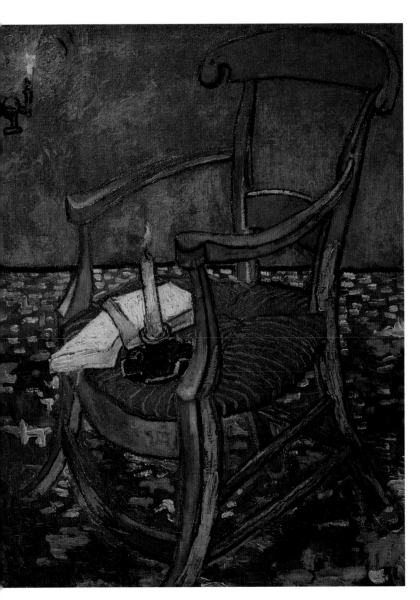

he was allowed out to paint the wheatfields, olive groves and cypress trees of the surrounding countryside.

Through Theo, *Irises* and *Starry Night* (p.60) were well received at the autumn Salon in Paris, with ten more pictures selected in March 1890, when Monet proclaimed Van Gogh's work the finest in the whole exhibition. Some paintings had also gone to the 'Les Vingt' show in Brussels and he made a sale for 400 francs, following a very favourable review by the critic Albert Aurier.

With his work gaining recognition at last, there was a feeling that Van Gogh had been locked away from normal life for long enough. Theo contacted a homeopathic physician named Dr Gachet and arrangements were made for Van Gogh to come north again, to stay under Gachet's supervision at Auvers-sur-Oise, near Paris.

At the beginning of May 1890, barely recovered from his latest psychotic attack, Van Gogh set off alone to spend four days in Paris with Theo and his new wife.

Those brief days in Paris, with endless visits from fellow artists, were to prove physically and mentally exhausting for Van Gogh. He retired thankfully to Auvers, where Dr Gachet had booked a room for him at the Auberge Ravoux.

Van Gogh soon set about painting pictures of the neighbourhood and his new acquaintances. Working intensively, he produced seventy-six paintings in the next two months. He experimented with a series that formed a panoramic celebration of country life: 'I'm all but certain that in those canvases I have formulated what I cannot express in words, namely how healthy and heartening I find the countryside.'

Early in July, Van Gogh made another trip to Paris. He wanted to see Theo and the family, and to meet up with Toulouse-Lautrec and Aurier, who had reviewed him so flatteringly the previous spring. It would seem that the brothers had a row about money and the

cramped conditions under which Theo was storing Van Gogh's paintings in their Paris apartment, and Van Gogh stormed off.

Back in Auvers, Van Gogh's relentless drive to paint – morning, noon and night – carried on until July. He wrote gloomily to Theo: 'I have risked my life for my work, and it has cost me half my reason . . .'

On Sunday evening, 27 July 1890, Van Gogh set out as usual for the wheatfields with his easel and paints. Apparently, he had announced that he wanted to shoot crows and someone had lent him a revolver. Instead, he shot himself in the chest, but not so badly that he couldn't manage to stagger back to the inn. There he collapsed, and both the local GP and Dr Gachet were summoned. Gachet sent a message to Theo, who arrived the next afternoon and stayed at Van Gogh's bedside for the remaining few hours of his life.

Night fell, and as Theo held Van Gogh in his arms he heard him say: 'I wish I could die like this.' With a bullet lodged beneath his heart and after one final epileptic attack, Vincent van Gogh died at 1.30 a.m. on 29 July 1890.

1

EARLY WORK

The earliest of Van Gogh's drawings, mostly from the 1870s, are promising in their composition and sense of place and atmosphere. Heavily influenced by the Dutch school of the day, they tend to be of limited colour range, with an emphasis on their tonality. Van Gogh seemed already to be seeing more than he could yet express, and there can be no doubt that he would have benefited from a drawing master to help strengthen his technique.

Looking at the pen and pencil drawings Van Gogh made of his lodgings, and the churches he attended, it appears that he occasionally resorted to using a ruler. These pictures are a straightforward attempt at accurate representation. The same precision would prove helpful in mastering such techniques as proportion and perspective.

While working for Goupil in London from 1873 to 1875, Van Gogh greatly admired the wood engravings to be seen in *The Graphic* and the *Illustrated London News.* He could not have chosen better, because the Victorian engravers were at the height of their skills and he never lost the graphic edge gained through studying their line and shading techniques. In the early 1880s he collected bound copies of these journals, not only for the reproductions of artists they featured but also because he admired the line illustrators they employed and had it in mind to submit some of his own drawings eventually.

In 1880, Van Gogh was given manuals on anatomy and perspective by a benefactor. From that point on, he taught himself to draw with new understanding and his skill began to develop, along with his choice of subjects – the working people he respected so much: 'My drawings are not yet what I want them to be . . . making progress is like miners' work.'

Five years later, Van Gogh's first painted masterpiece featured a peasant family in *The Potato Eaters* (p.24). His early efforts at painting can be seen to be much more indicative of his future as an artist than his early drawings.

This typical study is of an old man taking a break from his work, possibly in front of a fire. Van Gogh's handling of the pen and ink and charcoal has produced a rich textural drawing; the gnarled hands, whiskery face, hat and pipe give us a glimpse of the people with whom he was living at the time. There is a slight element of caricature about the drawing, just enough to suggest character but without distortion. The care taken over the clothes, hands and face suggest that the old man was sitting long enough to enable Van Gogh to include considerable detail.

Old Man with Pipe
Nuenen, 1883

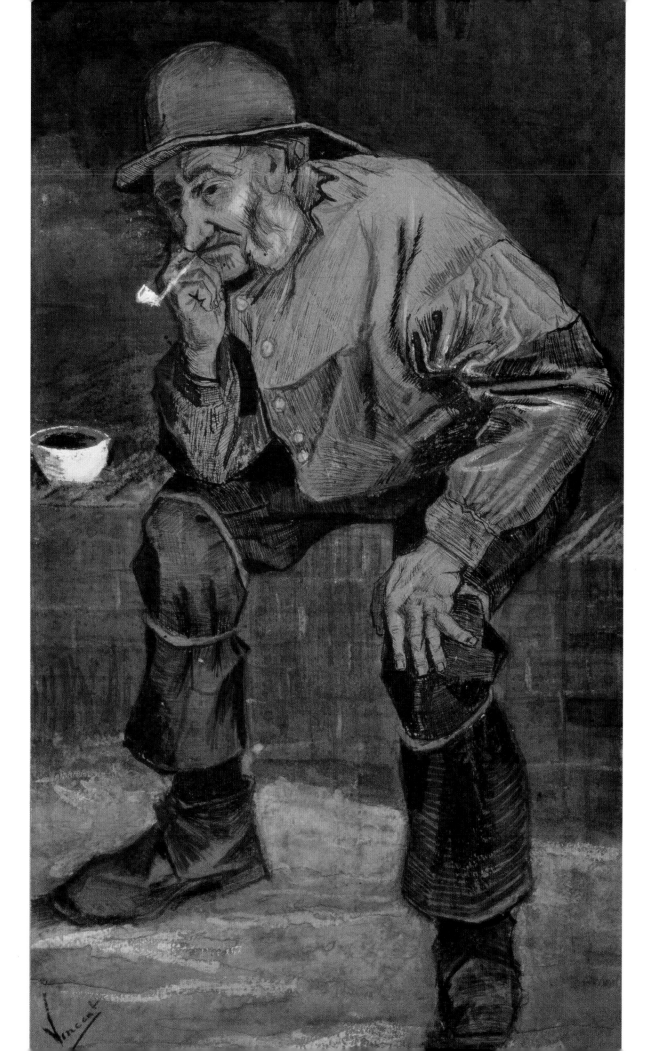

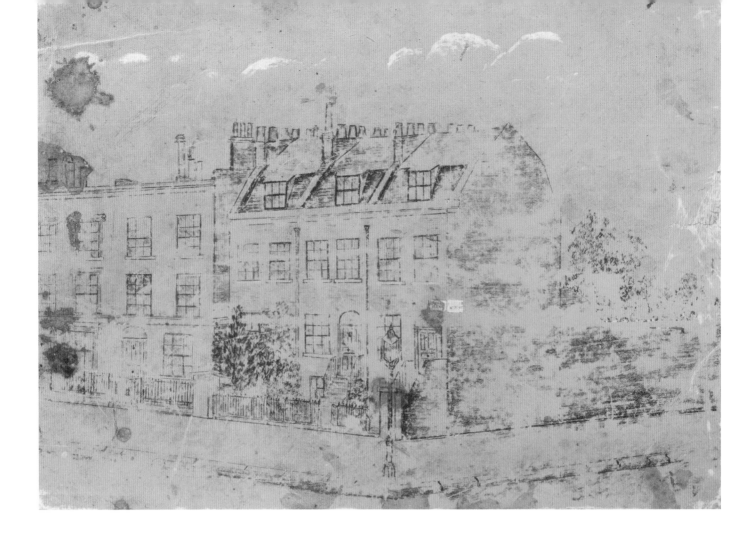

When Van Gogh was in England he went to the Royal Academy Summer Show and noted the beauty of the paintings by Tissot, a painter of society scenes. He admired many of the current artists and in a letter to his brother Theo gives a list of their names. He said 'most people did not admire enough' and urged Theo, who was already in the art business, to 'admire' as much as possible.

During his time in England Van Gogh mentioned that his love of drawing had decreased; nevertheless, he produced several drawings of buildings. One of the houses that he lodged in, owned by the Loyer family, he drew in painstaking detail using a technique often seen in engravings (above). It looks as if it has been measured and ruled up and shows a sure grasp of proportion and aesthetic values.

Van Gogh had an artist's eye for everything and wrote a graphic description of the scene from his train into London. A cultured and well-read man, he was conversant with English writers. He quoted from George Eliot concerning the evangelization of workers in London, and commented on the longing for religion among people in large cities. Van Gogh was much taken by painters who had a story or moral to tell, and he loved the work of the French painter Millet for this reason.

87 Hackford Road
London, 1873–4

Men and Women Miners Going to Work
The Borinage, 1880

This watercolour drawing was made by Van Gogh while he was in the Belgian mining district of the Borinage, or shortly after he left it. It serves as an example of his ability even before he began to draw and paint seriously. The handling of the figures is quite refined, but without the power he later developed. The background is well observed, although the strange bedraggled trees which conveniently fit the spaces between the figures appear somewhat contrived and are typical of an untaught amateur. Nevertheless, despite the shortcomings of this drawing when compared with the work he was to produce in the next ten years, the promise is evident. For example, the handling of the background buildings is relatively sophisticated and shows an understanding of perspective and mass.

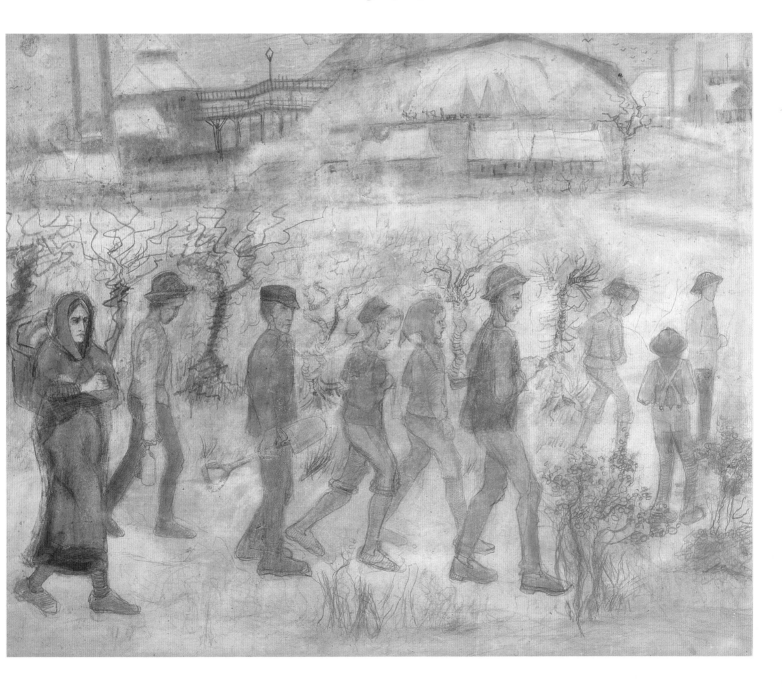

Here is an impressive drawing by Van Gogh, done while he was at Etten. It shows his efforts to improve his artistic abilities in drawing with his use of texture, tone and perspective. He has used the tones of charcoal and brown ink to add to the overall warm tone of the trees and then has contrasted this with a pale, whitish sky. His handling of the textural qualities drawn in line is masterly and demonstrates how his natural talent was beginning to show itself increasingly as he became more committed to the life of an artist. He was very keen to show that the underlying discipline of painting was drawing and he didn't neglect his studies in this area. Indeed, most of his very early work is simply drawing, although he did begin to paint intermittently, experimenting with both watercolour and oil paint. However, his colour values remained subdued and not very different in effect from his drawings.

Orchard near Etten
1881

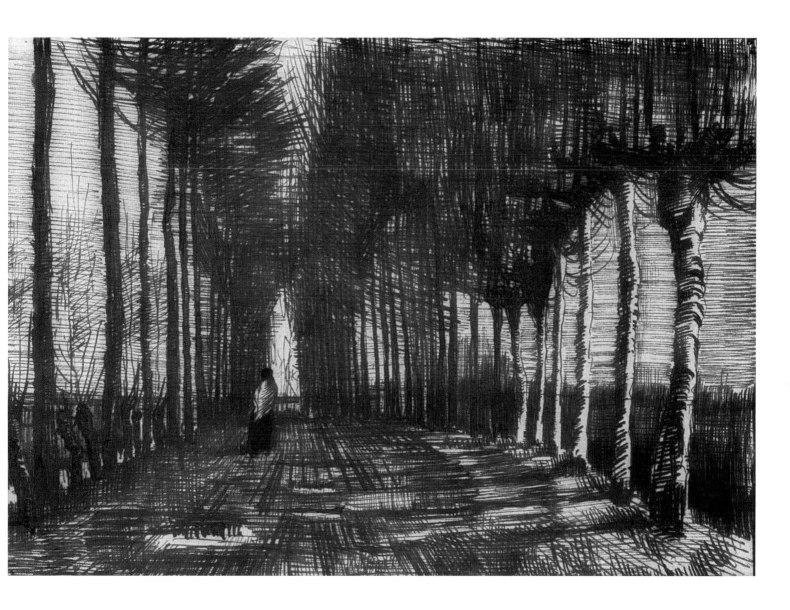

Figure on a Road
Nuenen, 1884

This rather classic scene, typically Dutch with its limited colour range and tonality, is in pen and brown ink on buff paper. The scene, of an avenue of trees with the sun casting long shadows across the road and a lone figure, was produced, among others, by Van Gogh while he was in Nuenen. It may be a drawing worked up from an outside sketch, or even partly copied from an older piece of Dutch landscape painting, and the technical proficiency of the drawing is remarkably good. The handling of the dark, overhead branches of the trees creates a satisfying texture which helps their highlighted trunks and the patchy light stretching across the road looks much brighter by comparison. The small female figure helps to give scale to the whole composition. Van Gogh seems to have made rapid, straightforward progress through the stages of learning about drawing and painting.

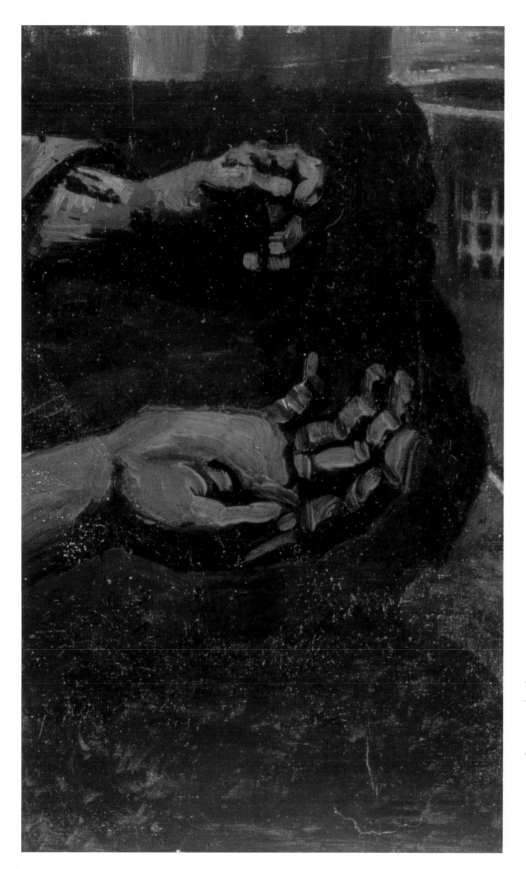

Hands
Nuenen, 1885

While working towards his large painting *The Potato Eaters* (p.24), Van Gogh spent a lot of time drawing details of peasant life. He produced at least forty studies of hands, heads and complete figures in different positions in order to work out his final composition. This work is one such study, although it was not eventually used in *The Potato Eaters*. The hand grasping the wooden handle of an implement is very strong and uncompromising, showing clearly the workmanlike quality of the fingers and knuckles. These are not a model's hands but the hands of a worker of the soil, full of strength and vigour.

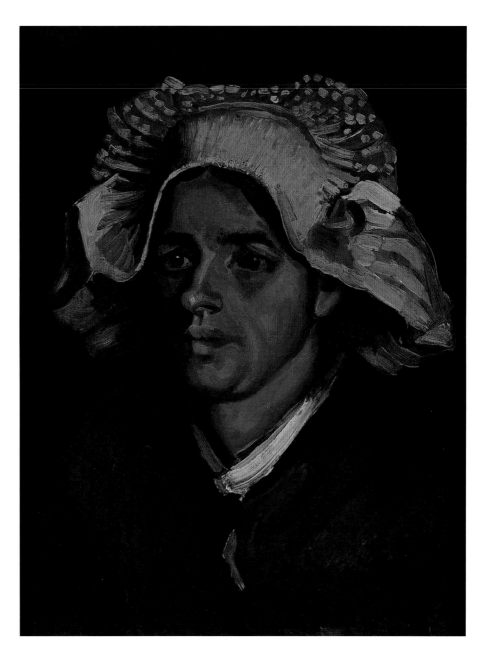

Peasant Woman's Head
Nuenen, 1885

Van Gogh's desire to show sincerely and truthfully the qualities of a peasant is apparent in this portrayal. The rather uneven features, the lumpy texture of the paint and the thick brushstrokes help to emphasize the earthy quality of the workers of the land, their flesh resembling the earth itself. The head is enhanced by the dark shadows and background, which help to dramatize the features.

Van Gogh did not regard his studies of heads as portraits of individuals but as depictions of facial types. He sought out 'rough, flat faces with low forehead and thick lips, not that angular [type] but full and Millet-like'.

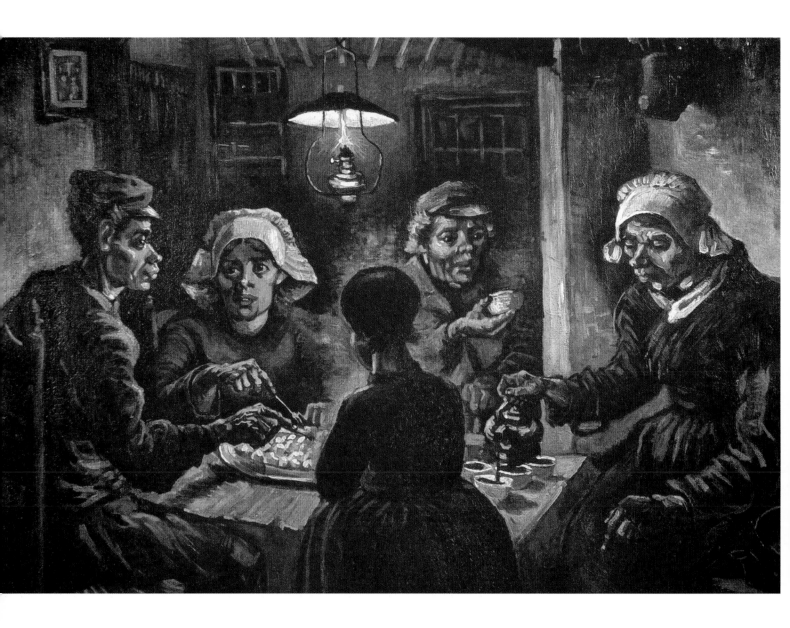

The Potato Eaters
Nuenen, 1885

By now Van Gogh had ended his happy domestic arrangement with his model and lover, Sien, as her mother had persuaded her to revert to her previous employment as a prostitute. Van Gogh's parents took him back into their home at Nuenen and helped support him while he worked as an artist.

At about this stage Van Gogh spent much of his time visiting peasant families in their homes to make drawings and paintings as studies for his first real masterpiece, a scene of a meal in a peasant community, *The Potato Eaters.*

This was Van Gogh's first large composition and is the culmination of his early efforts to become an artist. It is a masterwork that tells us that the artist hopes to achieve a place in the world of serious, professional painters. Van Gogh's aim was to portray a realistic image of the peasant people, to paint the real thing instead of an idealized picture, even comparing the peasants' complexions with the colour of the potatoes they eat. This work demonstrates how much Van Gogh had learned from spending time with the peasants and producing so many detailed studies of themselves, their homes and their lives.

Van Gogh's own view of the painting was: 'I have tried to emphasize that those people, eating their potatoes in the lamplight, have dug the earth with those very hands they put in the dish, and so it speaks of manual labour, and how they have honestly earned their food. I have wanted to give the impression of a way of life quite different from that of us civilized people. Therefore I am not at all anxious for everyone to like it or admire it at once.'

2
WORKING LIFE

All his adult life Van Gogh identified with working men and women; the industrial workers, servants and farm labourers – even prostitutes – whose rights were least considered by the middle and upper classes but whose labour was demanded unquestioningly.

In 1876 Van Gogh became keen to obtain 'a job between clergyman and missionary among working people in the suburbs of London', and to that end he took a job as an assistant to a Methodist preacher in Isleworth, a Thames-side village west of London. His religious fervour had come upon him the year before and he assured his brother Theo that this was the career he wanted to pursue. However, his career in England was short-lived: Van Gogh had an uncanny knack of rubbing people up the wrong way, and was often too zealous for his own good. The hard truth also was probably that he was not a good enough preacher, and his rough and ready appearance – in sympathy with his 'flock' – often left a lot to be desired.

On returning home, Van Gogh was unable to measure up to his father's hopes when he failed to obtain a theology degree in Amsterdam, nor did he impress the School for Evangelists in Laeken. Nevertheless, his commitment carried him as far as a probationary term with a mining community in the Borinage district of Belgium. There, he taught children, visited the poor and took Bible classes. But it was to no avail. His identification with the miners had gone too far, in the opinion of the governors. He was living alongside them, sharing their abject poverty and therefore not setting the correct aspirational example.

Without the shock of this rejection in 1879, Van Gogh might not have decided to abandon evangelism. However, he saw that he could portray the harshness of working life through art, rather than a sentimentalized version more acceptable to bourgeois tastes. With the encouragement of his brother Theo, he embarked on a career as an artist with his customary zeal and commitment.

Van Gogh's studies of peasant women, bent over, working at a tiring activity, give the viewer an understanding of his models. This black chalk drawing is of a very high standard, especially the massing of shapes to create powerful expressions of toil. His chalk strokes are now rapidly drawn and confident: each adds to building a convincing picture of volume and materiality. If we compare this drawing with *Peasant Woman Digging* (p.36), it is evident that his constant drawing practice is paying off in both mediums. The figure conveys the vigorous strength of the peasant and the integrity of her labour.

Peasant Woman Stooping and Gleaning
Nuenen, 1885

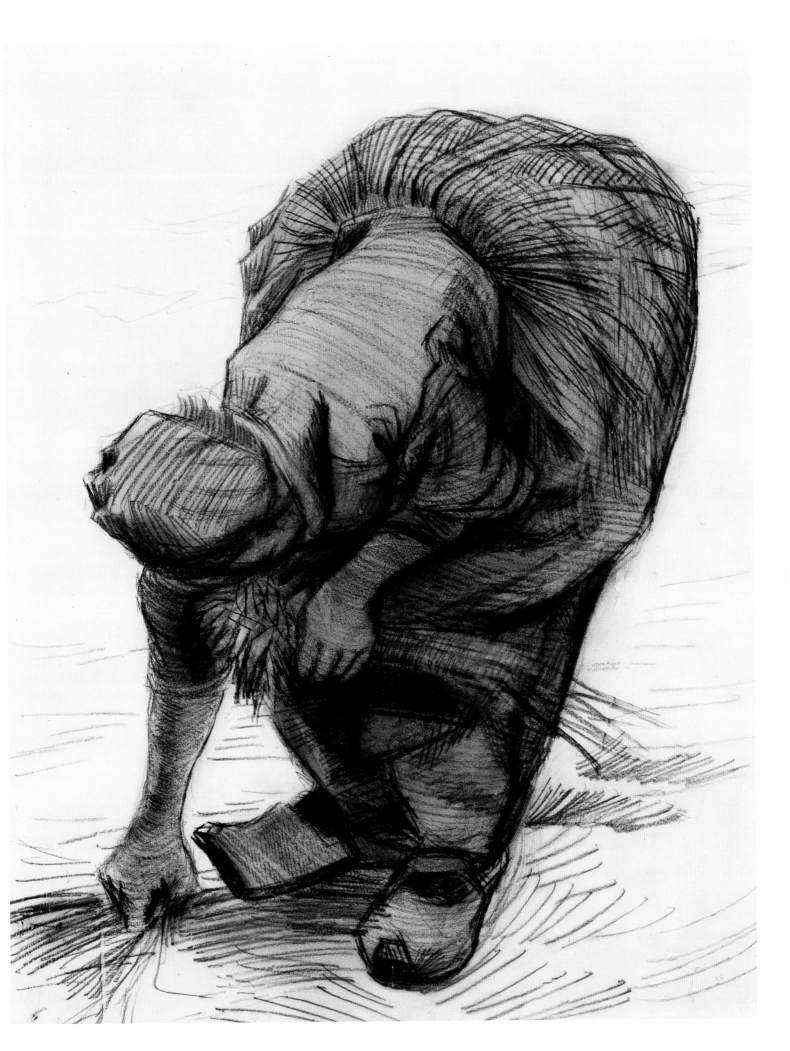

This work of a countrywoman sewing, painted in watercolour and heightened by white, was painted by Van Gogh partly while she was posing and partly from drawings. It shows how his understanding of the values of texture and tone produced a scene that is full of depth and interest while remaining simple. The marks are fine and produce a rich but muted colour scheme rather in the tradition of Rembrandt and his followers. Van Gogh's ability to balance tonal values so effectively is clear in this portrayal of atmosphere and image, and is evidence of his progress as an artist.

At this time Van Gogh proposed to his widowed cousin Kee Vos, who was staying in Etten, but was rejected. At first she remained on friendly terms with him but returned to Amsterdam when he continued to declare his love for her. He tried to follow but was prevented from seeing her again by her family and friends. He said, 'That higher feeling which I cannot do without is love for Kee. Mother and Father argue in this way: she says No, so you must resign yourself. I do not see the necessity of this at all, on the contrary . . . In order to work and to become an artist, one needs love.'

Writing about her later, Van Gogh said, 'She lived in a modest, simple little room; the plain paper on the wall gave it a quiet grey tone, yet warm like a picture by Chardin.' This painting has all the quality of a Chardin figure and one wonders whether it was an attempt to recall Kee Vos's image in the guise of a seamstress.

Seamstress from Scheveningen
Etten, 1881

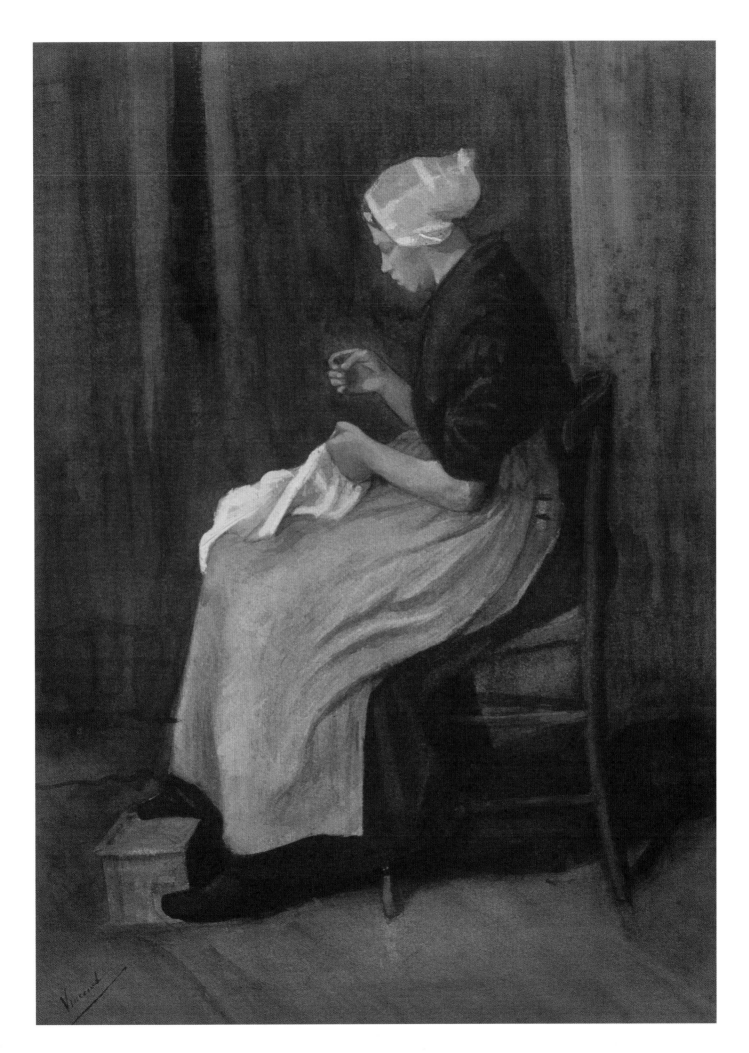

om een half jaar moedeloosheid te veroorzaken
waarna men toch eindelijk ziet dat men niet zich
had moeten laten Desorienteeren —
Van twee personen ken ik den zielstrijd tusschen
het ik ben schilder en ik ben geen schilder.
Van Rappard en van myzelf — een strijd soms bang
een strijd die juist is dat wat het onderscheid is tusschen
ons en zekere anderen die minder serieus het opnemen
voor ons zelf hebben wy het soms beroerd aan 't eind
eener melankolie een beetje licht een beetje vooruitgang
zekere anderen hebben minder strijd ~~dan~~ minder werken
misschien makkelyker ook het ~~niet~~ persoonlyk
karakter ontwikkelt zich ook minder. Gy ~~zoudt~~ ook
dien strijd hebben en ik zeg weet van uw zelf dat gy
het gevaar om door lui die zonder twyfel magrer beste
intenties hebben van streek te worden gebragt —
Als als in u zelf zegt u gy zyt geen schilder — schilder
dan juist Kerel en die stem bedaart ook maar
slechts daardoor — Wie als hy dat voelt gaat naar
vrienden en zyn nood klaagt verliest iets van
zyn mannelykheid iets van het beste wat in hem is —
Uw vrienden kunnen slechts zyn diegenen die
zelf daartegen vechten door eigen voorbeeld van
actie hy active in u opwekken —

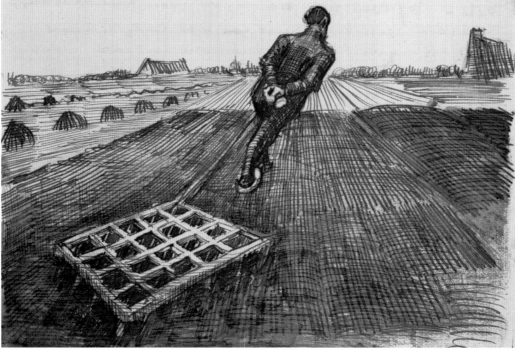

eggen is my w
zyn eigen paar
hier. Gy moe
8'eranderen —
Gy hebt gedurend
3sen — me met
gaat gy verder.
Gy kunt beslist
Een woord van G
gevonden —
~~man~~ zu
zekere resolut
woord het is ee
aan lui uit wier
denkt redenatie
ze te veel hoort
ravengekras —
wat is dat die
niet eens zeggen
al dat ravengekra
dat grof — zelf
zou men gee
leeren van de
zeen zachtjes
van de dingen —
good Dong ver
te zullen graven
zeyn gaan. Ik ge
wat vind om over
maar wil men
vallen — Das
grond van Drenth
verdroog niet
ziet je zeggen —
op den Korenakker

Man Pulling a Harrow
Drenthe, 1883

This early drawing, included in a letter to his brother Theo, has an element of Van Gogh's later symbolic theme of a lone figure in a field. This particular figure does not appear to have any real symbolic meaning, but its dominating presence in the flat landscape is obviously something which struck Van Gogh as central to the composition. All the lines of hatching, which demonstrate his ability to create perspective, converge towards the vanishing point of the horizon, which is bounded by a hedge. On the way, these lines of perspective, of the furrows, hay stooks and so forth, direct the eye towards the upper torso of the figure and place him in the centre of the picture. The heavy texture of the man's back and legs creates a feeling of his strength and solidity, while the hefty four-square harrow helps to emphasize the flatness of the foreground.

The angle of the man's body as he strains against the harrow's weight expresses how hard the work is – in fact the implement should probably have been pulled by a horse, if the peasant could afford one. This picture does not necessarily express the dignity of labour but rather expresses Van Gogh's appreciation of the hard life that peasants had to contend with.

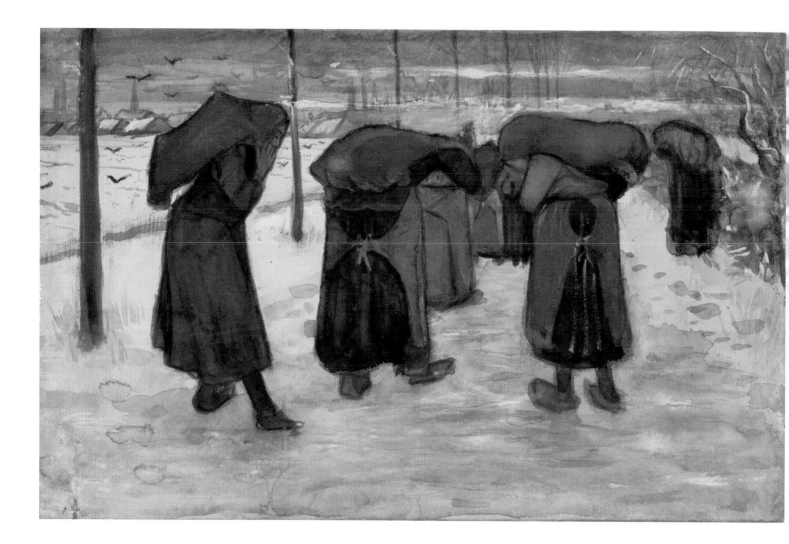

This watercolour heightened with white is a bleak picture of the laborious toil of these women who carry heavy bags of coal on their heads and shoulders and trudge through the snow of a cold Netherlands winter. The drab browns and blues of the dark figures clearly silhouetted against the snowy ground, the regular bare trees spaced out along the road and the black shapes of birds in the fields are highly evocative. The viewer can sense Van Gogh's sympathy for these women.

He groups the figures into a huddle in the centre right of the scene, and although the placing of the group proceeding along the road is well observed, the nearest figure looks a little posed and was probably drawn at another time and then used in this picture. However, the composition has some power and an understanding of how the dark group creates a sense of trudging effort. This attempt at a complete and thought-out composition shows the strength of Van Gogh's determination to be an artist.

Women Miners
The Hague, 1882

Weaver Near an Open Window
Nuenen, 1884

In this painting, Van Gogh produces a very convincing interior reminiscent of Rembrandt in its tone and colour. With the clearly drawn framework of the loom set in the space of the small cottage of the weaver, the low-key colour values are realistic in their feeling of an unembellished working environment.

The quality of light coming through the window highlights the surfaces of the woven cloth and the upper edges of the structure of the loom. The light also catches the profile of the weaver, with his gaunt, angular face and knobbly hands. Through the window can be seen a church, and a woman bending to weed or plant; the gentle green of the land suggests the warmer months of the year.

What is clear is how Van Gogh shows the dominating character of the loom in the room, as it seemingly cages in the weaver. The look or character of the weaver has no real individuality, but one registers him as an earthy type. The composition is both powerful and sympathetic, and the feeling of the enclosed space is very palpable.

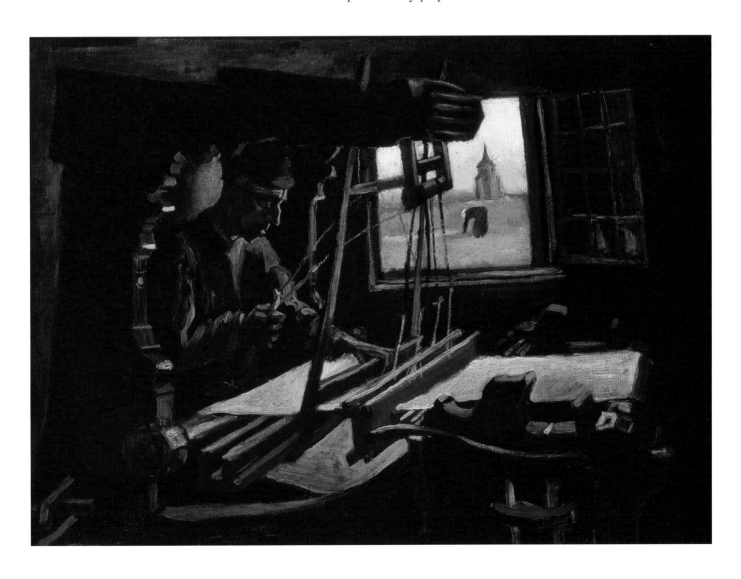

Van Gogh kept on working on the theme of the local peasant population of Nuenen and continued to draw from life. This painting of a woman winding bobbins is similar to other works he produced of peasant weavers in their cottages. These paintings are typified by their very low-key colour values and are almost tonal paintings, which may or may not be accurate as far as colour is concerned. It is certain that at this time the influence of painters such as Rembrandt tended to keep Van Gogh's range of colour limited to dark browns and greys with an occasional dash of white or yellow to liven up the tones.

It is noticeable how beautifully he showed the structure of the machinery, the interiors of the cottages and the concentration of the weavers working. Van Gogh depicted the truth of the hardness of peasant life, and the sombre colours give some idea of his own belief in the unremitting grind of the human lot.

Peasant Woman Winding Bobbins
Nuenen, 1884

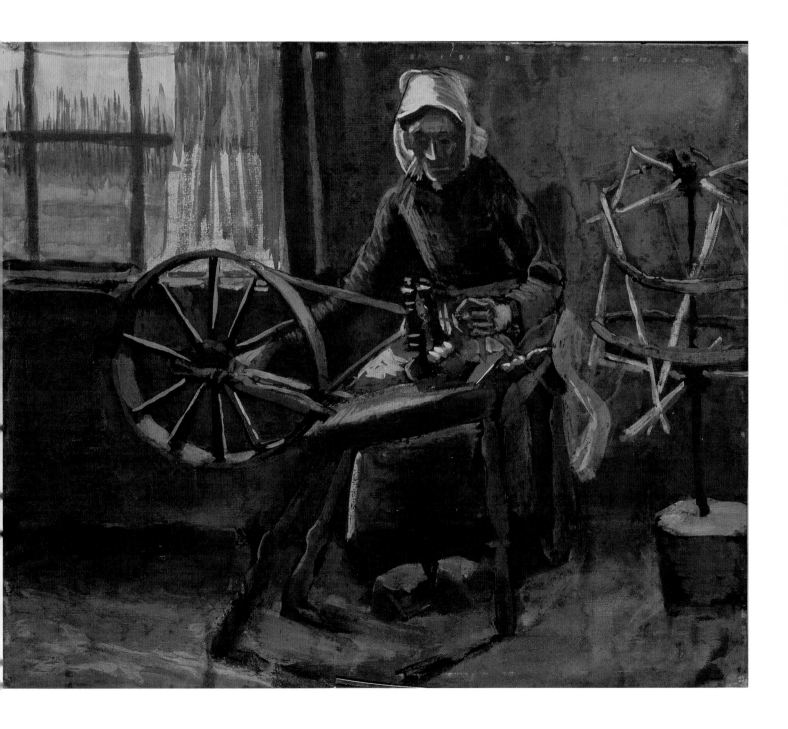

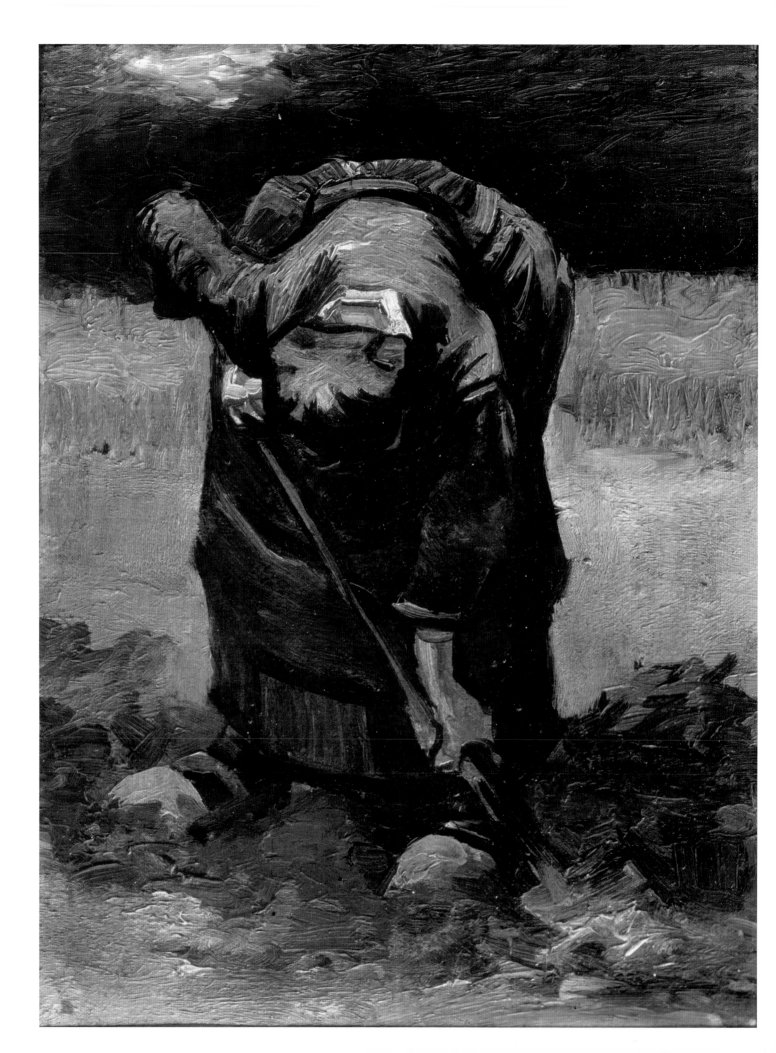

Peasant Woman Digging
Nuenen, 1885

The strong figure of the bent woman thrusting her spade into the earth is beautifully set against the sunlit hay in the field behind her. The dark upper part of the background suggests trees and helps to throw into emphasis her sunlit back and head, giving a strong sense of dimension and substance. The ruggedness of her shape, highlighted by the use of angular lines, and the sharp contrast between the brightly lit areas and the strong, dark shadows of the folds in the cloth, shown up in the dark mass of her skirt, give great solidity to her shape. The way her bulging clogs catch the light and the depiction of the dark base of the skirt add a steadiness to the working figure. Van Gogh's observation of the movement of the woman is particularly good, although this image would probably have been worked on from sketches rather than painted directly from life. The lighter tone of the hands draws the eye to the focus of the work, the toil of digging.

This painting exemplifies Van Gogh's increasingly confident manner of handling paint, in this case with the use of heavy impasto: his exceptional talent is beginning to make itself felt.

3
ARTISTIC INFLUENCES

Van Gogh's correspondence with Theo gives plenty of hints as to the influences that guided his artistic career. Sometimes he reeled off lists of artists who had caught his eye, many of whom have since been forgotten.

Van Gogh grew up with the Dutch school, and the dark early palette of his paintings can be attributed to this influence: early on, he tended to be swayed by the subject of a picture rather than its artistic merits.

During his two years in London, Van Gogh visited many galleries, including the National Gallery and the Royal Academy. He became familiar with masters such as Titian, Tintoretto and, in particular, the 'very beautiful' Constable, whose work stood out because it reminded him of Daubigny, one of the French Barbizon school that he handled at Goupil. Reynolds, Romney, Gainsborough, Bonington, 'Old' Crome and Turner were acknowledged

but not dwelt on. Nor had Van Gogh very much time for those on the contemporary English scene, apart from John Everett Millais, Tissot, and George Henry Boughton, a painter of doomed lovers and historical narratives.

Examining Van Gogh's earliest efforts, we see he was clearly following a very traditional line evident across Europe and America at the time. As he matured, his attention was drawn to artists such as Monticelli, the French artists Breton and Millet, Delacroix, Corot, and Daumier, with his biting social commentary.

Once Van Gogh moved to Paris with Theo in 1886 he mixed daily with the avant-garde, readily exchanging pictures with them. He seemed to keep himself open to a wide range of influences all his life but, even in his last years, would return to the diggers and sowers who always had a special place in his affections.

This is one of many self-portraits that Van Gogh painted while he was in Paris in 1887. He was beginning to experiment with new painting techniques, in this case with what might be called Neo-Impressionist or perhaps semi-Pointillist, influenced by Seurat and Pissarro. His short, stabbing brush-marks are evidence of his attempt to encompass the ideas developed by the Impressionists, laying strokes of one strong colour against other strong colours so that the viewer's eye blends the pure colours to produce the tones of light the artist is attempting to portray. Van Gogh was pleased with this painting, in particular the halo effect of the background which gives some visual order to the multifarious brushstrokes of which this work is composed.

Self-Portrait with Grey Felt Hat
Paris, 1887

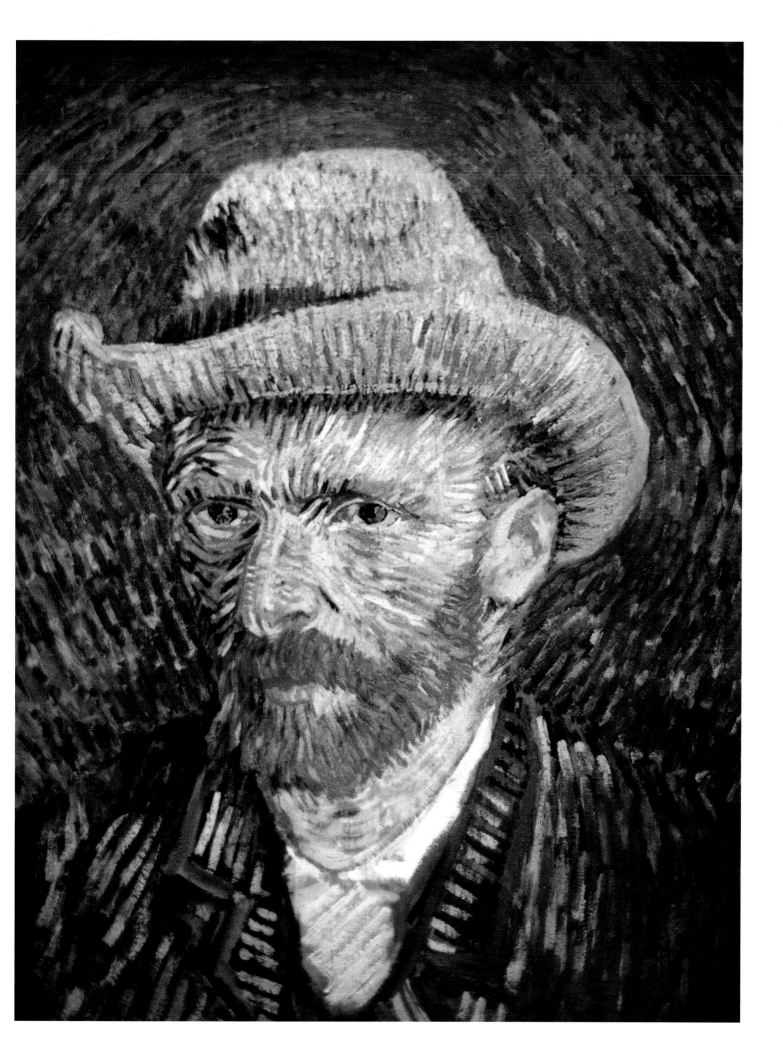

In this painting Van Gogh was observing and trying to learn from Emile Bernard, a painter he had met in Paris and become friendly with. Bernard and Gauguin (another of Van Gogh's artist friends) had been to Brittany to paint the local figures in their traditional costumes. Trying to ignore the normal rules of perspective, they produced works whose great pattern-making qualities were obtained by using strong colours and simplified shapes against flat backgrounds.

Van Gogh's effort to make an Emile Bernard painting resulted in something similar to a Bernard, but his strong line in drawing kept breaking through. Bernard had sent Van Gogh photographs of his canvases, of which Van Gogh had said: 'The trouble with them is that they are a sort of dream or nightmare – frankly the English Pre-Raphaelites did it much better'. But he also said: 'He [Bernard] is a Parisian from top to toe, and to my mind a model of vivacity.'

Breton Women and Children (after Bernard)
Arles, 1888

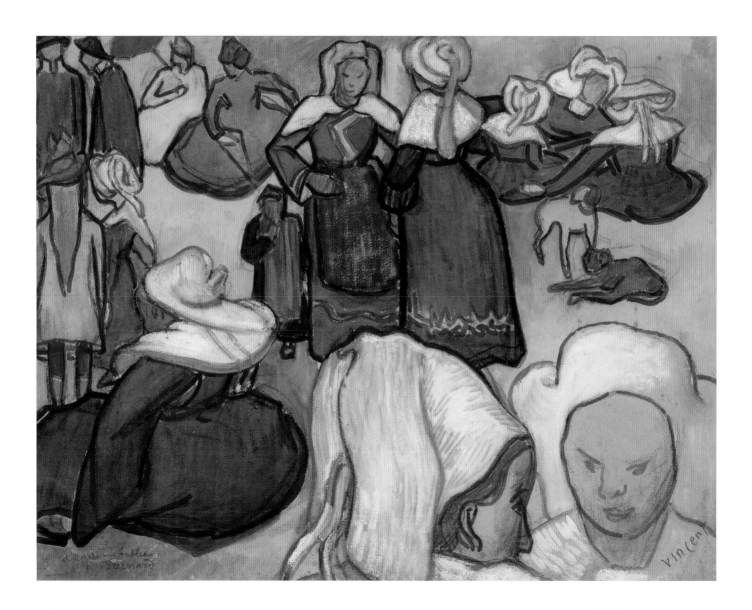

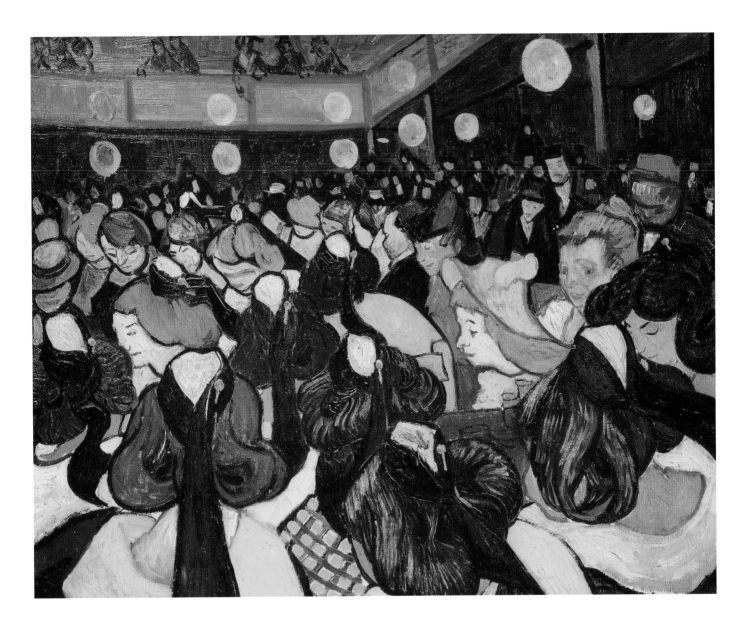

The Dance Hall
at Arles
1888

In this evocative painting of figures flooding across the dance hall in Arles, Van Gogh's flat handling of the colour contrasts follows a similar direction to Toulouse-Lautrec's graphic paintings of the Moulin Rouge series, while the cheerful colour and crowds of bodies are reminiscent of Renoir's *Moulin de la Galette*.

When Van Gogh was in Antwerp he visited a sailors' ball at the docks, and wrote of the girls: 'There were several very handsome girls, the most beautiful of whom was plain-faced. I mean, a figure . . . in black silk, most likely some barmaid or such, with an irregular, ugly face but lively and piquant . . . it does me good to see folk actually enjoying themselves.'

Paintings of people enjoying themselves in a natural way were pioneered by the Impressionists, such as Manet, Renoir, Monet and Degas. They thought that instead of the traditional works so highly regarded by the formal art world they should record the common activities of the modern population and present them on an almost heroic scale.

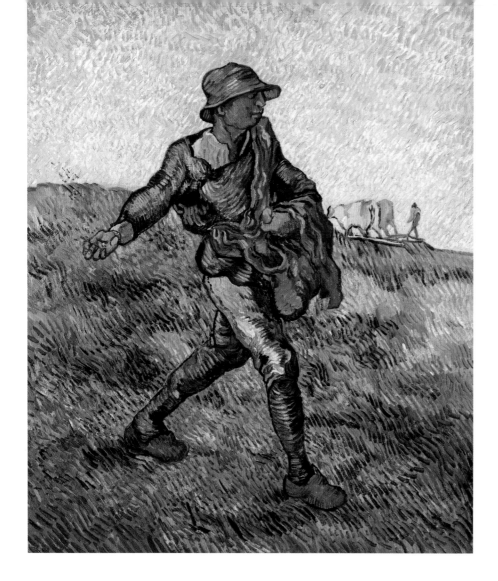

Throughout his life Van Gogh referred to paintings by the French painter Millet, who was a strong influence on his work. He made copies of paintings by Millet throughout his career, originally with similar colour values but later on with more intense colour, thus changing the effect of the picture.

The sower in Millet's painting was a rather noble and heroic figure, whereas Van Gogh saw the working peasant more realistically: strong but not noble, wresting his living from the earth by the sweat of his brow and with a lifetime of unremitting toil. This view of the peasant is demonstrated in the way Van Gogh always portrayed peasant figures: gnarled, almost stunted shapes, but with a vigour that looked as though they had grown from the earth itself. In Van Gogh's version of *The Sower*, Millet's forms are adhered to fairly closely, but somehow the drama and romance of the Millet figure have been subsumed in the rather awkward movement of Van Gogh's subject. The peasant's work now appears much harder and his appearance is grim, like an early version of *The Reaper*: the sower sows the seeds of man's futile existence while the reaper cuts it down again.

The Sower (after Millet)
St-Rémy, 1890

Noon: Rest from Work (after Millet)
St-Rémy, 1890

In his later copy of Millet's work, *Noon: Rest from Work*, which he painted in St-Rémy in 1890, Van Gogh shows the resting haymakers in the shade of the haystack as drawn-out, knobbly, awkward human shapes with none of the grace of Millet's figures.

Van Gogh likened Millet's work to a gospel and his drawings to a good sermon: 'I consider Millet, not Manet, to be that essentially modern painter who opened a new horizon to many . . . and what Michelangelo said in a splendid metaphor, I think Millet has said without metaphor, and Millet can perhaps best teach us to see, and get a faith.'

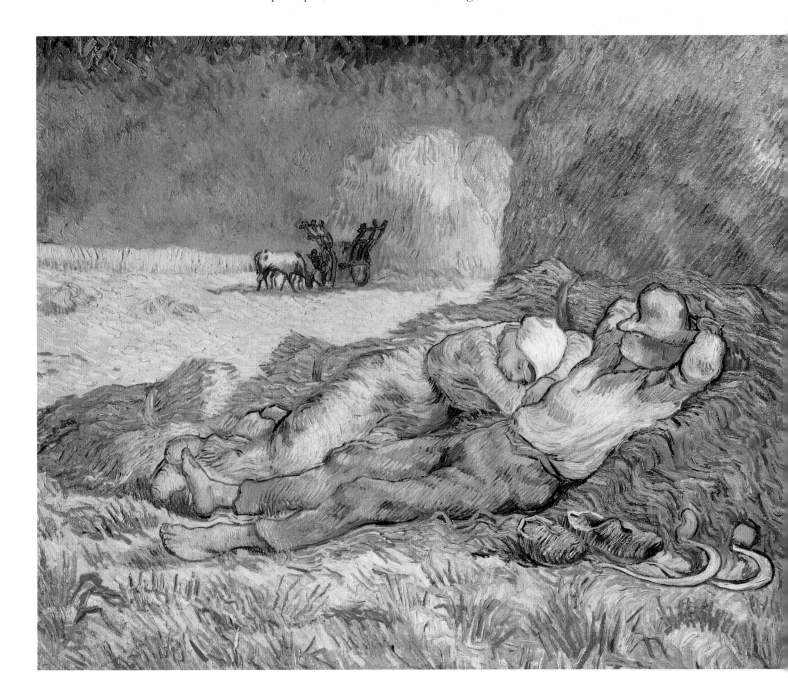

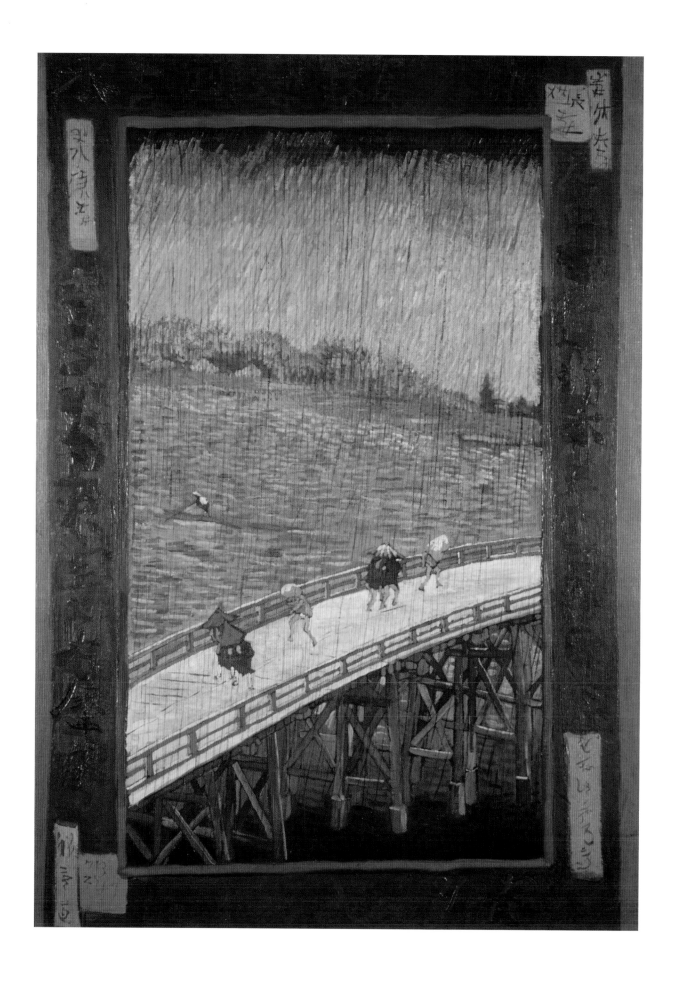

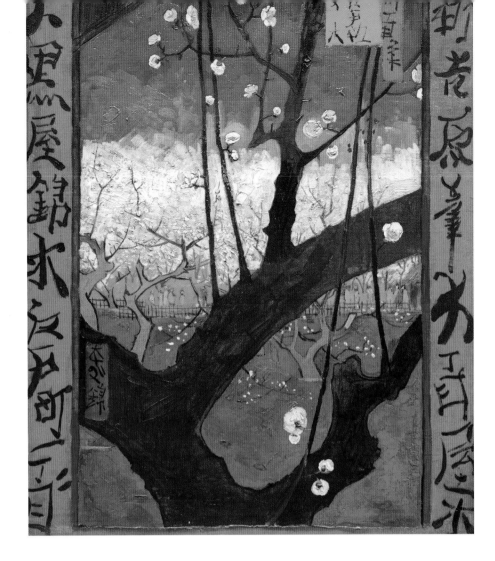

The Bridge in the Rain and Flowering Plum Tree (after Hiroshige)
Paris, 1887

Van Gogh painted these images while working from some of the Japanese colour prints which had taken the art world by storm since their introduction to western Europe in the 1860s. They certainly fascinated Van Gogh and influenced his style: he owned twelve images of this type and had several on the walls of his studio. These two copies are typical of Van Gogh's attempts to reproduce their style and form but to intensify the colour. He has also added borders, thus making them his own works in the style of Hiroshige rather than straightforward copies. He was very struck by how little the Japanese master was concerned with depth and perspective. Van Gogh was by now interested in freeing his own work from perspective and allowing colour to produce the necessary dimension.

Van Gogh was so intrigued by the Japanese prints that he organized an exhibition of them at the Café du Tambourin, which influenced many of the Impressionist and Post-Impressionist painters.

This portrait of Madame Ginoux from the café in Arles was painted by Van Gogh directly from a drawing of Gauguin's that he admired. While at Arles, Van Gogh said that he 'was powerless to paint the women of Arles as anything but poisonous', which was directed at Degas, who had talked of 'saving myself up for the Arlésiennes'. It is likely that this remark referred to Van Gogh's wish that his house in Arles would house a community of artists who would come and paint the glories of Provence before moving on further south.

While at St-Rémy, he painted at least five versions of Madame Ginoux from Gauguin's drawing. Madame Ginoux was ill and Van Gogh was concerned about her health; consequently he was allowed out of the hospital to go and give her one of the paintings. He wrote to her and her husband, saying, 'I write to you . . . my dear friends in order to try to distract our dear patient for a moment, so that she may once again show us her habitual smile and give pleasure to all who know her.' After his visit, Van Gogh failed to return to the hospital and was found by an attendant wandering helplessly about.

Van Gogh's admiration for Gauguin's work was boundless and he was certain that the art world needed artists such as Gauguin, with the strong hands and stomachs of workmen, with more natural tastes, more loving and more charitable. Van Gogh called him 'a virgin creature with savage instincts. With Gauguin blood and sex prevail over ambition'. He wrote to Gauguin about this portrait: 'I tried to be religiously faithful to your drawing, while nevertheless taking the liberty of interpreting through the medium of colour the sober character and the style of drawing . . . it is a synthesis of the Arlésiennes, if you like; a summary of our months of work together . . . to be understood by you, and by a very few others, as we would wish it to be understood.'

The Arlésienne (Madame Ginoux) (after Gauguin) St-Rémy, 1890

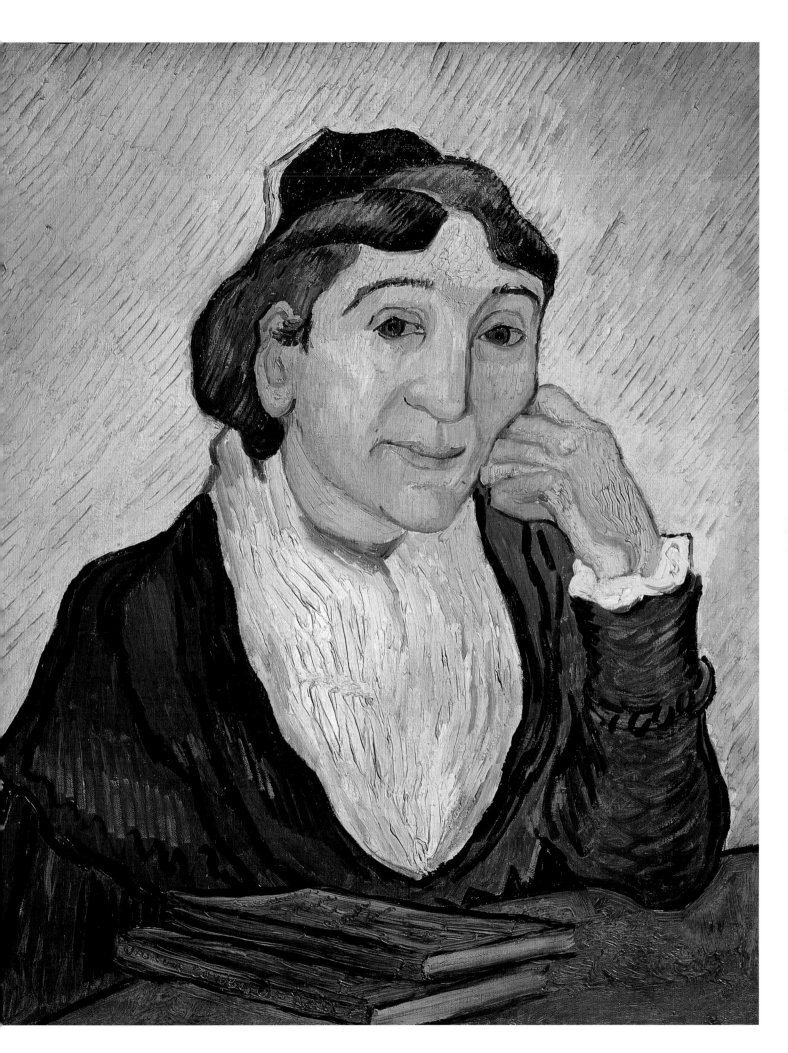

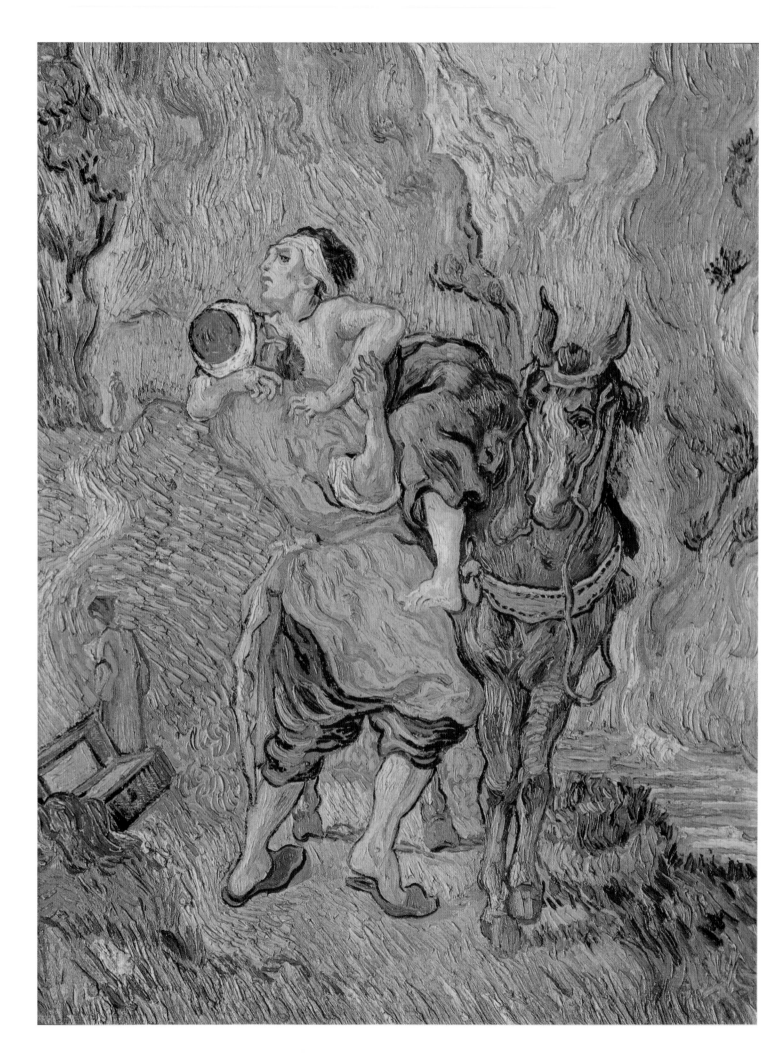

The Good Samaritan (after Delacroix)
St-Rémy, 1890

Van Gogh likened himself to Delacroix towards the end of his life when he knew he had little time left. Like Delacroix, he worked as one possessed, pouring forth drawings and paintings at an impressive rate: 'I discovered painting when I no longer had any teeth or breath left.' His version of Delacroix's *The Good Samaritan* is a careful copy of composition. However, Van Gogh's new sense of colour and technique turns a romantic version of the parable into an explosive, rippling flow of colour and curling form. The figures no longer have Delacroix's grace and bravura but look desperate and awkward, while the very landscape flames with extraordinary greens, yellows, blues and violets. The action of the two main figures is energetic but they grapple like wrestlers, while the mule or donkey looks unbalanced and staggering.

Van Gogh painted this while in the hospital at St-Rémy, when it was difficult for him to paint outside. Working on this painting may well have helped his temporary improvement. He wrote: 'The figure of Christ, as I feel it, has been painted by Delacroix and Rembrandt . . . and later Millet painted . . . the doctrine of Christ.'

4

SUN AND THE SOUTH

As Theo had predicted, once Van Gogh arrived in Paris in 1886 he had been unable to resist the Impressionists' overturning of moribund Academy rules. His palette had undergone a radical revision, from the dark tones that had produced *The Potato Eaters* (p.24) to the glorious colours of fresh flowers.

In February 1888, Van Gogh boarded a train to Arles, in the south of France. His mental health was deteriorating; he also ate too little and drank far too much. But once spring arrived, he began to paint with an abundance of energy, soon producing work of a wholly new quality. Gradually, the strong colours and brilliance of the sun in Provence affected his palette; deeper blues and more vivid yellows and greens competed with warm oranges and reds. This intensity of colour bursting out of the paintings made during his time in Provence is now recognized as Van Gogh's greatest contribution to modern painting: 'Colour expresses something by itself,' he declared.

It is an extraordinary fact that during the eighteen months between his move to Arles and his death in Auvers-sur-Oise, Van Gogh achieved most of his major works. His landscapes demonstrate how much his development as a painter owed to the countryside, but even his portraits and interiors seem to take from the climate and landscape the same powerful effect of strong colour under brilliant light.

Even during spells of mental disturbance, Van Gogh's treatment of colour didn't falter. He was surprisingly methodical and strove deliberately for the effects he was after; if an impression of darkness was given, it was to provide a contrast that would throw up a still brighter image. It is interesting that when he painted memories of the north, he kept to the stronger palette combinations that the southern sunlight seems to have released. Thankfully, the darker elements of his psyche did not hold back this outpouring of light and power.

This painting is just one of Van Gogh's evocations of a southern night illuminated by a starry sky. The sky glows behind the darkened houses while in the foreground is the brilliantly lit terrace of the local café with lamps, tables and chairs and people seated at the far end enjoying the warm night. The quality of the paint is rich and brushed on in thick short strokes to create the curved cobblestones, stone-walled buildings, Mediterranean pines and glowing starlit sky. The dark and light figures against the background are put in economically, with swift brushstrokes.

Café Terrace at Night at Arles
1888

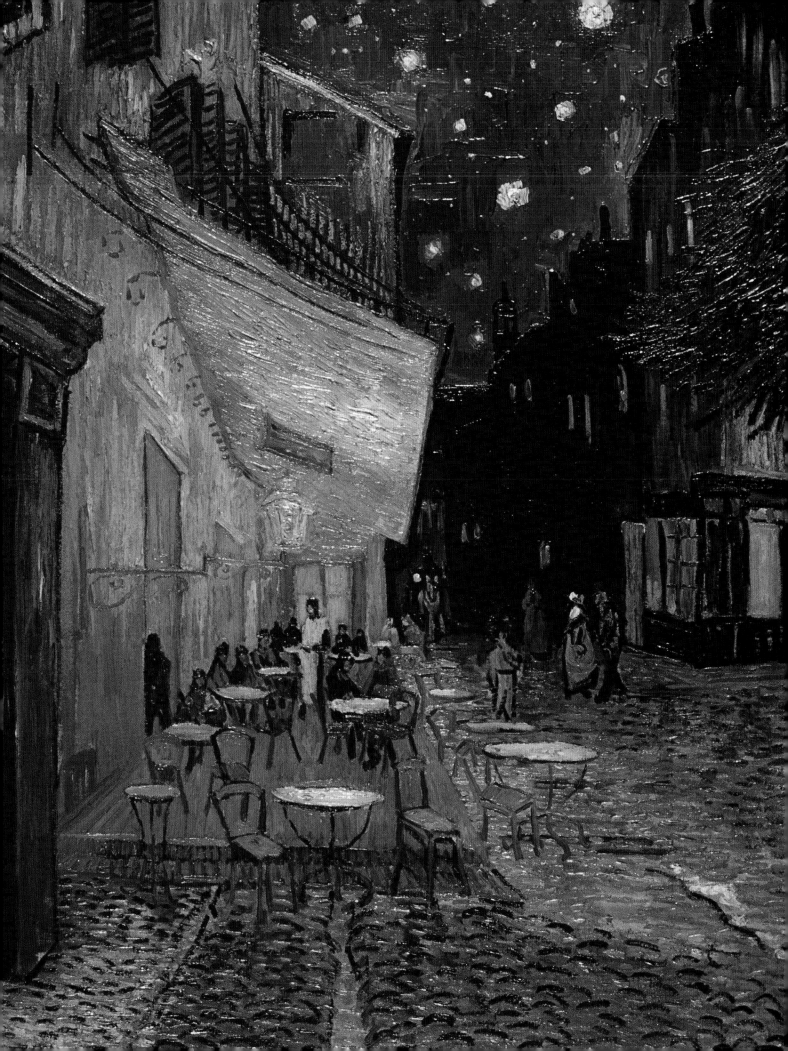

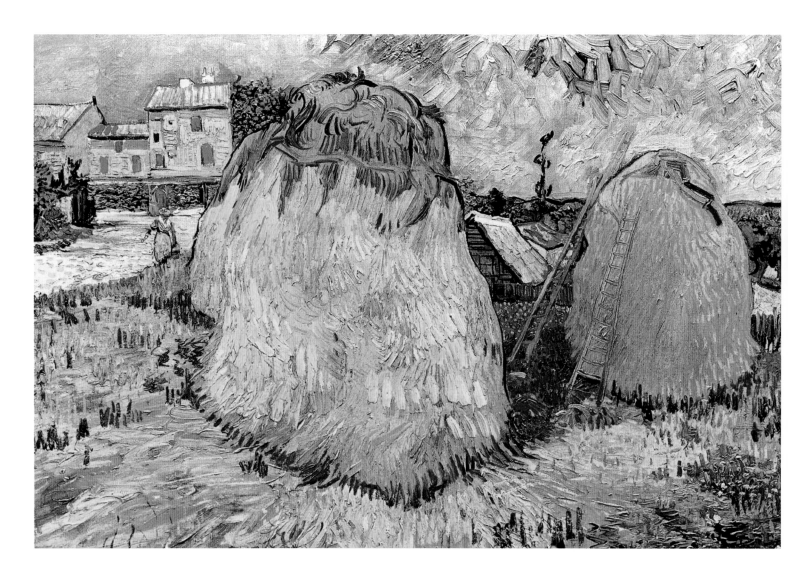

This is a brilliant sunlit scene of haystacks, with a cluster of farm buildings in the middle distance and a line of blue hills on the horizon. For Van Gogh, the regular rhythm of the seasons, particularly in Arles, was immensely powerful and he was not afraid to place his haystacks centre stage, with the yellow stubble anchoring them to the land. The strong fresh greens of the trees, grass and the shutters on the farmhouse provide a vivid contrast.

These are not like Monet's haystacks, which show the way light can dissolve the solidity of an object until you cannot be sure which is more material, the air or the object. These objects have a solid form, seen in bright sunlight, without any of the ambiguity to be found in the more watery atmosphere of northern Europe. The figure of the woman carrying the pail in the background gives a sense of scale to the close-up view of the stacks of drying hay.

Wheat Stacks in Provence
1888

The Yellow House
Arles, 1888

The Yellow House was where Van Gogh hoped to start a colony of artists dedicated to painting the sun-drenched south of France, possibly when on the way to Africa. He said that he would have liked to go to Africa had he been younger, but felt that France was the furthest he could venture. This was partly due to lack of money but also because of his uncertain health.

Van Gogh only had use of the right side of the house in this painting, in Place Lamartine, Arles, but he hoped to redecorate it to be a true artist's house, cheaply yet with character. He was most impressed by the colour contrast of the yellow house against the deep blue of the summer sky. The pink house with the green shutters under the trees at the left side of the composition is the restaurant where he ate each day. Unfortunately his dreams of an artists' colony did not materialize; Paul Gauguin came to stay but departed because of Van Gogh's strange behaviour.

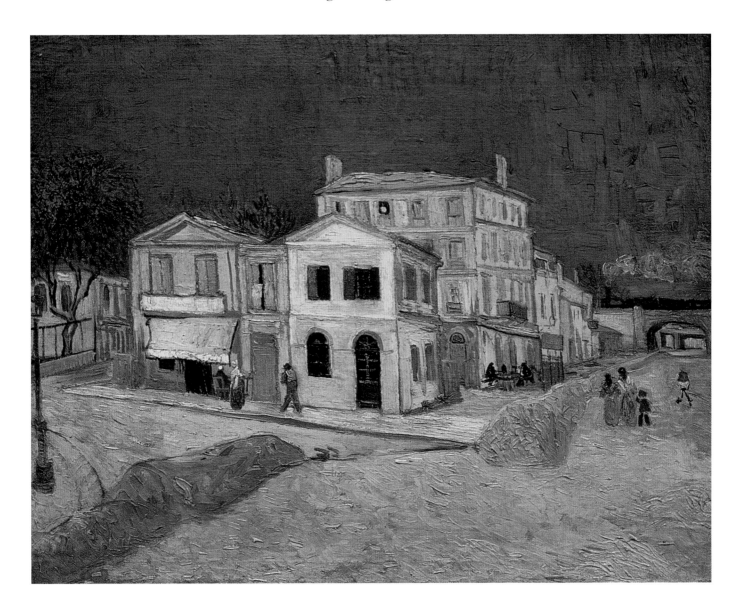

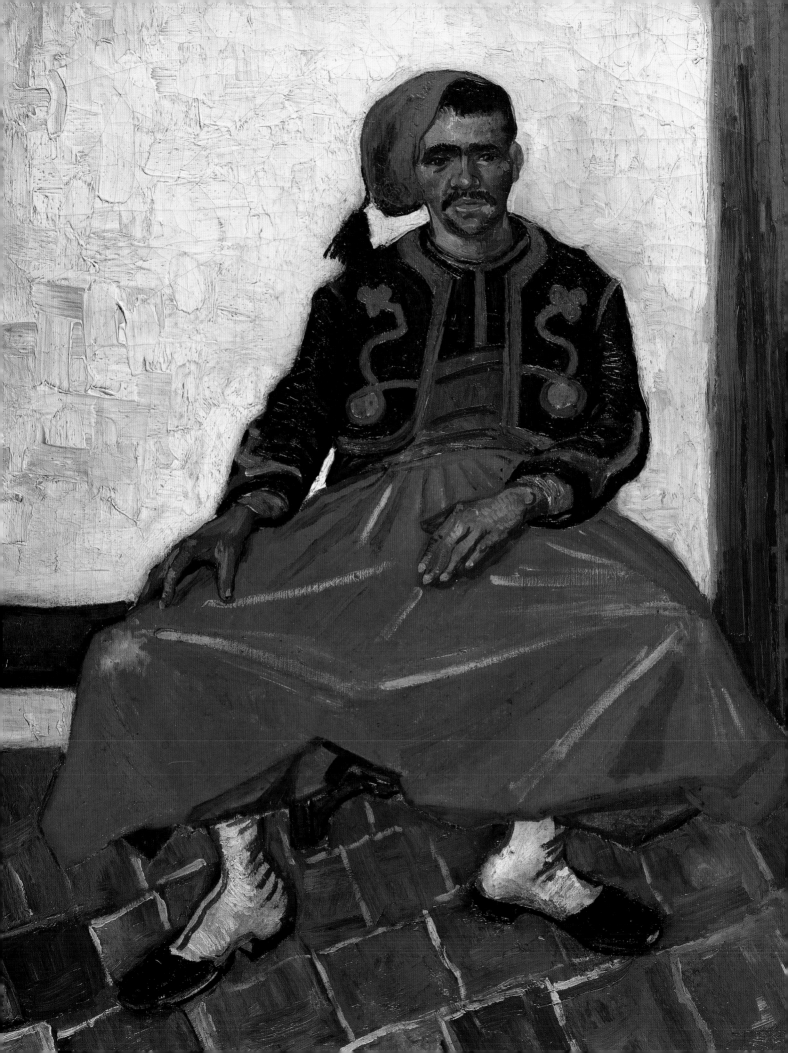

The Zouave
Arles, 1888

This is a portrait that Van Gogh found very hard to paint because of the difficulty of putting together the strong colours of the uniform that contrasted with the ruddy brickwork beneath the soldier's feet. Certainly his red headgear, the piping on his dark blue jacket and his dark-skinned face create sharp colour contrasts that could easily flatten or break up the portrait. However, Van Gogh seems to have managed to pull it together, although he wrote to his friend Emile Bernard that 'It is harsh and all in all ugly and failed.' He wanted to produce paintings of common people with all the raw combinations of colours that this might entail, but he felt that he had not learnt to reconcile these difficult effects.

This elite French infantry regiment – the Zouave – was one of the French Empire's units that was raised and served in North Africa. Van Gogh was taken by the dashing uniform with baggy britches, a soft red fez, a large cummerbund and exotic braiding on the jacket. He spoke of the soldier as 'A boy with a small face, a bull neck and a tiger's glance', characteristics which he certainly managed to capture in a difficult but powerful image.

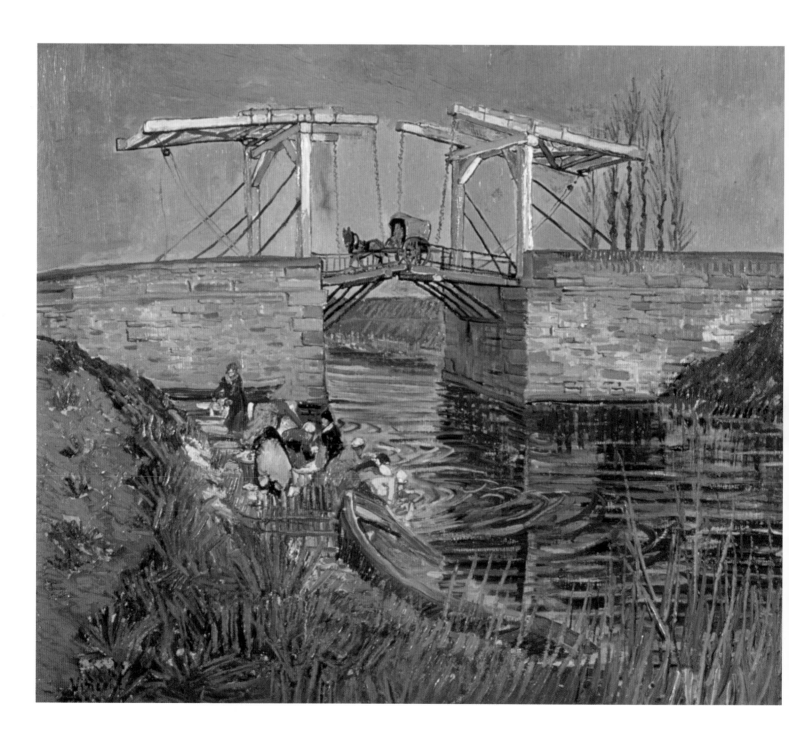

Drawbridge with Carriage
Arles, 1888

When Van Gogh first arrived in Arles in February 1889 the whole of the Midi region was covered in snow. It had been one of the coldest winters for a long time, and it lasted well into March. It was not until April that he was able to paint outside properly, and then we begin to see the effect on him of this new landscape and its bright, southern light.

This bridge across a canal reminded him somewhat of Holland and caught his fancy as a subject. The painting is one of a number of versions on this theme. The carriage is just passing over the bridge and a group of women wash clothes at the edge of the canal, in which there is a half-submerged boat. These elements produce an idyllic scene of calm activity and the combination of the blue sky, the carefully constructed drawbridge and the water reflecting the sky in its gentle ripples produces a very rich composition. While an earlier painting of the same place shows a much greyer sky with the structure of the bridge looking much duller, this version glows in the strong sunlight, picking out the yellow tones.

Once again Van Gogh proves how magnificently he could paint a work completed outside; clearly observed and with an immediacy of technique that brings out the solid dimensions of the scene. The structure of the wooden bridge is carefully observed so that one can sense the materiality of it, while the vegetation beside the canal softens the solid squareness of the stone-built section of the bridge against the emptiness of the sky beyond.

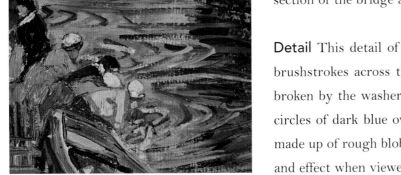

Detail This detail of the painting shows how Van Gogh has used parallel brushstrokes across the surface of the water where it is calm. Where it is broken by the washerwomen's actions, he swirls the water with tight semi-circles of dark blue over the lighter blue body of the water. His figures are made up of rough blobs of colour which nonetheless work brilliantly in form and effect when viewed from a distance.

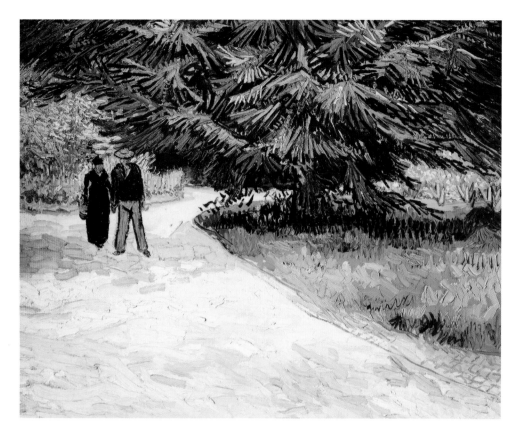

Left: **Public Garden with a Couple and a Blue Fir Tree**
Arles, 1888

Right: **Entrance to the Public Garden in Arles**
1888

Van Gogh did several versions of these views while in Arles and, as previously in Paris where he had painted lovers in a garden, may have been thinking of a *fête champêtre*, a view of tamed nature with people enjoying the setting. He thought that the area around Arles was similar in character to the landscapes in Japanese prints and said, 'I always pretend that I am in Japan here; and that consequently I only have to keep my eyes open and only have to paint what impresses me in my immediate surroundings.'

These paintings were intended to help decorate his house, so that when Gauguin arrived – for a long stay, Van Gogh hoped – he would find his room decorated with colourful paintings of the area around Arles. The paintings illustrate Van Gogh's developing technique: thick impasto strokes of colour, making the marks follow the contours of the forms, so that not only the tone and colour but also the actual paint texture give evidence of the space.

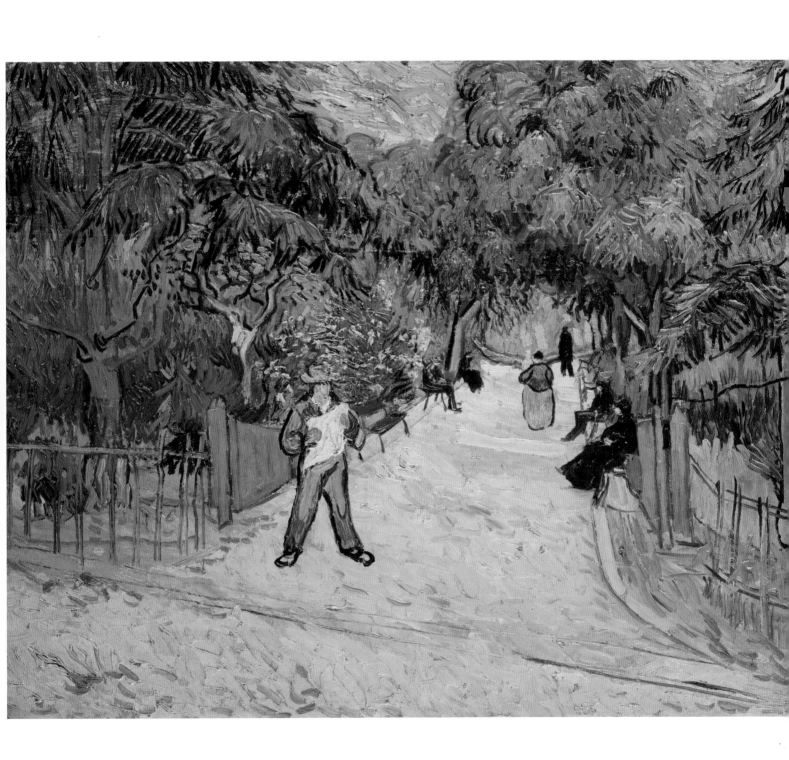

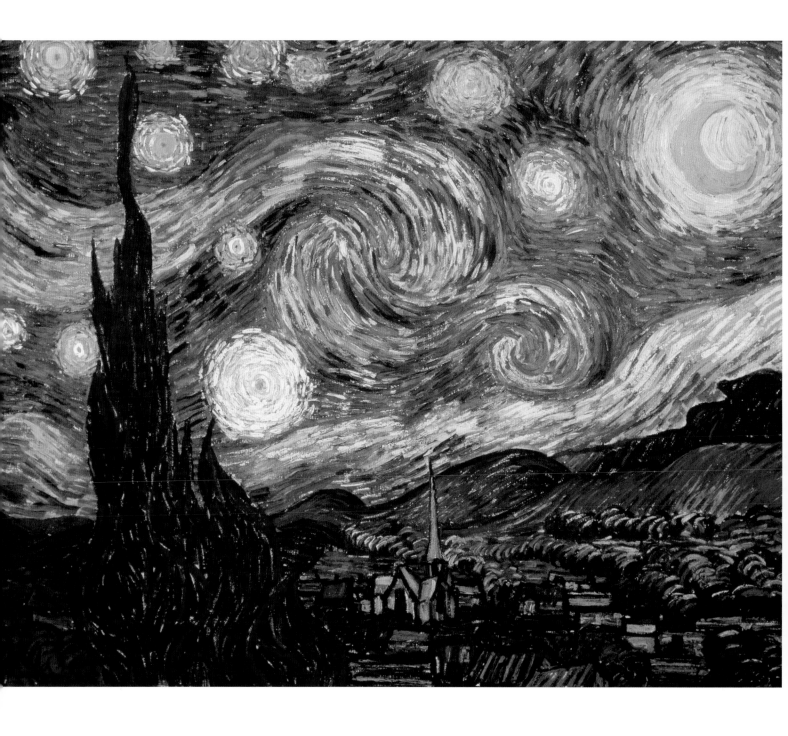

Starry Night
St-Rémy, 1889

'One night I went for a walk by the sea along the empty shore. It was not gay, but neither was it sad . . . it was . . . beautiful. The deep-blue sky was flooded with clouds of a blue deeper than the fundamental blue of intense cobalt, and others of a clearer blue, like the blue whiteness of the Milky Way. In the blue depth the stars were sparkling, greenish, yellow, white, pink, more brilliant, more sparklingly gem-like than at home – even in Paris: opals you might call them, emeralds, lapis lazuli, rubies, sapphires. The sea was very deep ultramarine – the shore a sort of violet and faint russet, as I saw it.' So Van Gogh describes the night sky by the coast in the south of France in the summer of 1888.

When he came to paint his famous picture he obviously called on his memories of this type of night stroll. Van Gogh painted an extraordinarily powerful firework display of glowing stars, golden crescent moon and swirling blues, which seems to be partly clouds and partly the movement of the heavens themselves. Across the glowing sky the dark flames of the deep green cypress tree writhe upward in silhouette. The deep blue landscape, huddled under rounded hills, has a few windows glowing yellow with light in the darkened town, but the real illumination is in the sky which makes the land look dark in comparison.

Van Gogh said of the cypress, 'It is as beautiful of line and proportion as an Egyptian obelisk. And the green has a quality of such distinction. It is a splash of black in a sunny landscape.'

5
INTIMATE SURROUNDINGS

Many of Van Gogh's paintings were closely connected with his personal life and surroundings. One of his Paris pictures shows the view from his room, marking his life-changing arrival there in 1886. The images of his rush-seated chair and of his bedroom at Arles are as familiar to us as our own rooms and possessions.

Van Gogh always seems to touch the viewer and probably never so much as when we're looking at one of his self-portraits. He painted and drew more than forty, most of them while he was living in Paris with Theo. He had hoped that portraiture would be a money-earner and invested in a good-quality mirror so that he could practise on himself. The result was an ongoing record, not only of Van Gogh's appearance but also his attitude towards himself. As in the case of Rembrandt before him, the self-portraits are a history of his life as an artist; he even painted two portraits with his severed ear covered in bandages.

Some of his portraits are of his family, including a gentle little oil painting of his mother and charcoal sketches of his father, Theodorus van Gogh, that were made from photographs. He also painted his favourite sister, Willemina. It was his brother Theo's suggestion that Van Gogh might work from photographs at times when models were scarce.

After threatening Gauguin and harming himself, Van Gogh struggled to carry on a normal existence in Arles. In May 1889, he chose to enter an asylum several miles away at St-Rémy. The doctors there immediately confined him to the house, so that they could keep him under observation. Making the most of the situation, Van Gogh set up his easel and painted the views from his window. These paintings, together with the letters to his brother Theo, give us a substantial view of Van Gogh's personal life, his passions, his mental stress and his remarkable artistic development.

This sympathetic portrait of the daughter of Dr Gachet, Van Gogh's doctor and friend at Auvers-sur-Oise, is painted thickly with solid brushstrokes in a mixture of whites which predominate over light blues, pinks and greens. The wonderful, rhythmic movement of the strokes of white paint down the folds of the skirt somehow evoke a musical atmosphere. The piano, with its black, angular outline, is painted almost crudely, but makes the figure look softer and gentler in contrast. This is a charming picture, which is remarkable given the psychological disturbances that Van Gogh was suffering at this time.

Marguerite Gachet at the Piano
Auvers-sur-Oise, 1890

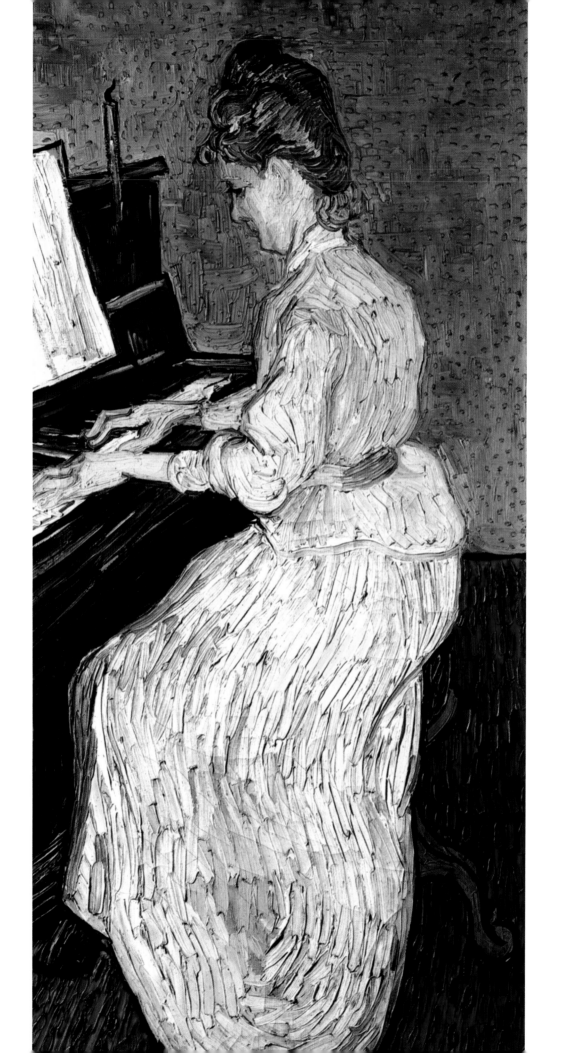

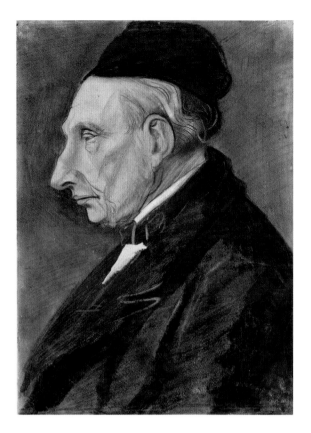

Portrait of Theodorus van Gogh
Etten, 1881

Portrait of the Artist's Mother
Arles, 1888

These portraits of Van Gogh's parents were painted seven years apart, and his father was dead by the time his mother's portrait was made. The picture of Theodorus was painted at Etten and offers a rather cold, unsympathetic view of the clergyman, who seemed to find his eldest son more of a trial than a benefit. The features look rather tired and repressed and give the impression that Theodorus was not a particularly successful practitioner of his vocation; respectable rather than godly, correct rather than compassionate. Van Gogh had many disagreements with his father, who told him on more than one occasion to leave the house; their religious beliefs and understanding of the teachings of Christ were very different. Theodorus did not understand his son at all and frequently despaired of him, which provoked violent reactions from Van Gogh. In his turn, Van Gogh despaired of his father's narrowness of vision, based on what he thought of as 'clergyman's vanity'. The unfortunate consequence was that their relationship had little chance to develop happily.

The portrait of Van Gogh's mother was made from a small black and white photograph of her. He wrote at the time, 'I am working on a portrait of Mother. Because the black and white photograph annoys me so. Ah. What portraits could be made from nature with photography and painting. I always hope that we are still to have a great revolution in portraiture.' Certainly this portrait seems to have seen beyond the photographic image. Van Gogh has created a distinctly animated portrait of his mother; her eyes gleam with life.

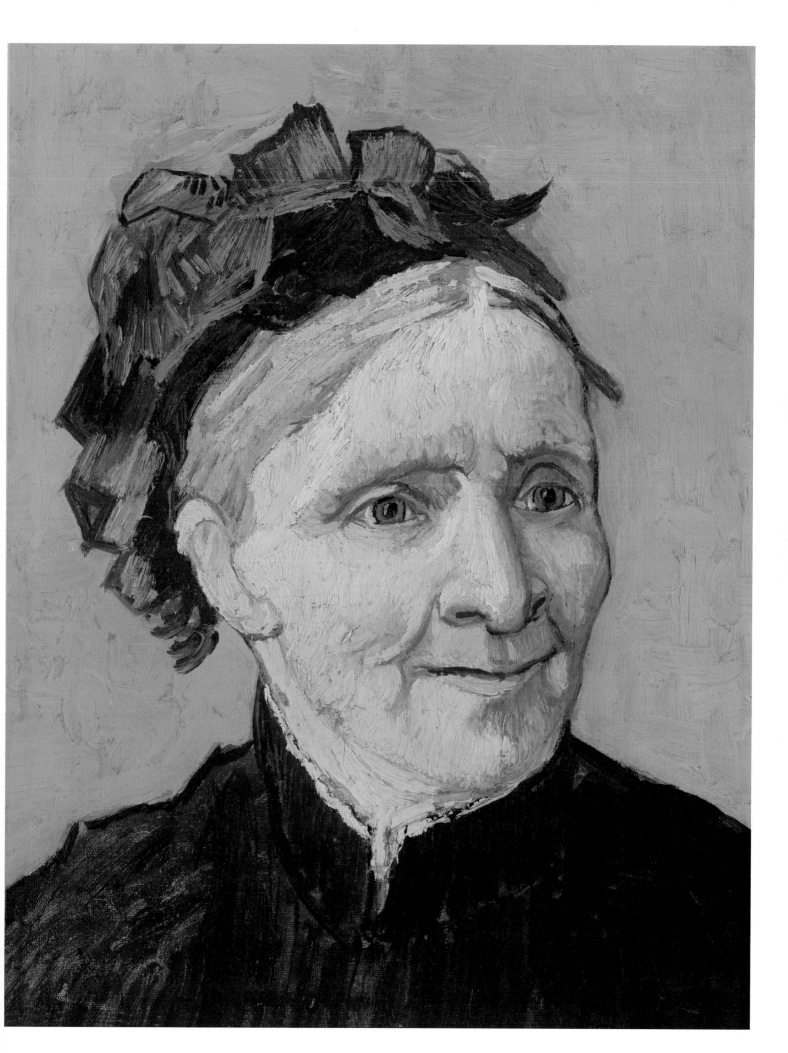

This chair matches those shown in Van Gogh's bedroom, and given his modest means it is indeed probably one of them. It is a simple chair of the type used by peasants: wooden, upright, with a seat woven from straw or rushes, in the yellowish tone of the natural materials. On the seat are Van Gogh's old pipe and a tobacco pouch, suggesting his view of himself as a simple working painter with few personal needs or possessions.

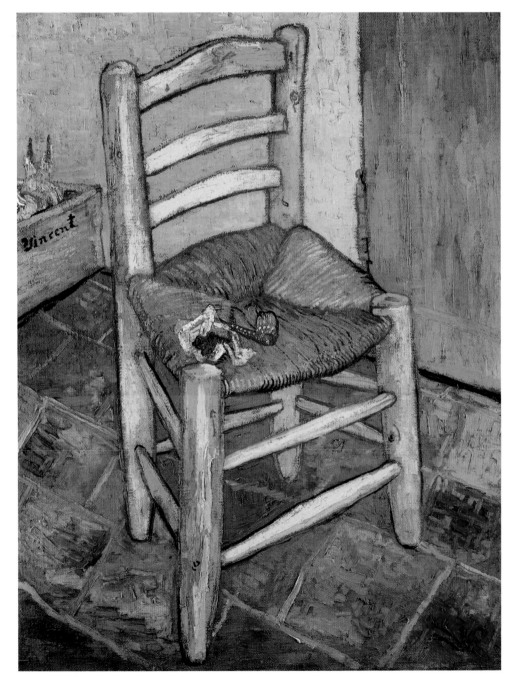

Van Gogh's Chair
Arles, 1888

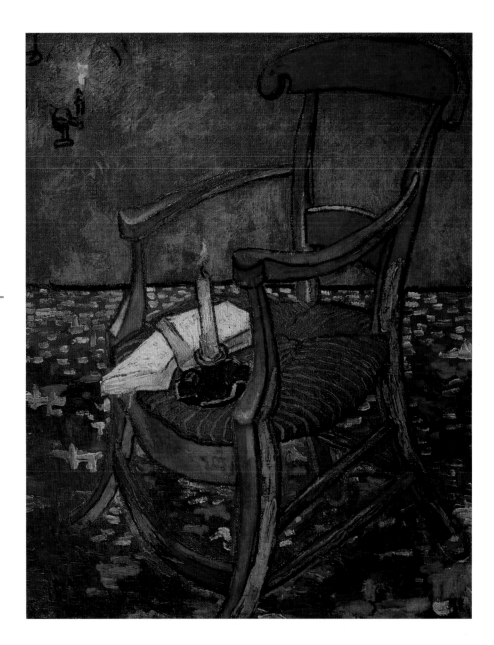

Gauguin's Chair
Arles, 1888

Van Gogh painted Gauguin's chair first, as a celebration of his friend coming to live with him in the Yellow House at Arles. This chair implies a different character altogether, and one which Van Gogh appears to have found rather impressive. The chair was probably the best one in the house, being of a more sophisticated design than the yellow chair. The seat is more intricate and the objects on the seat – two yellow-covered books and a lighted candle in a holder – suggest the intellectual power of enlightenment that Van Gogh expected from Gauguin. The carpeted floor, of possibly the best room in the house, and the lamplight on the wall speak of a more urbane world than does the simple tiled floor and what looks to be a box of plants by Van Gogh's chair in his own room.

Two chairs, painted perhaps as symbols of the people who used them? The chairs are generally thought to represent the status of the two friends as seen from Van Gogh's point of view.

The famous painting of Van Gogh's bedroom in Arles has been reproduced so often that it is as familiar to many people as if they had lived there themselves. The rather small, plain room, which holds just a bed, a small table and a couple of chairs, is drawn and painted with influences from Japanese prints, in which there are no cast shadows and the colour is kept bright and clean. The slightly odd perspective of the far wall gives an effect of an acute angle in the corner at the bedhead, but it may just be Van Gogh's attempt to add a little extra depth to a room seen from the opposite corner. Van Gogh was too much of an expert in perspective for it to be unintentional, so he must have been consciously ignoring the strict rules of linear perspective.

The foreshortening of the bed and chairs and table set at different angles to one another give a feeling of the viewer being almost at a child's eye level. The warm colour of the bare floor contrasts with the pale blue walls and the green shutters give a hint of the sunlight outside, making this small room seem cheerful and comfortable. The warm yellow of the furniture also gives the impression that Van Gogh was decidedly happy while painting this picture.

The Bedroom
Arles, 1888

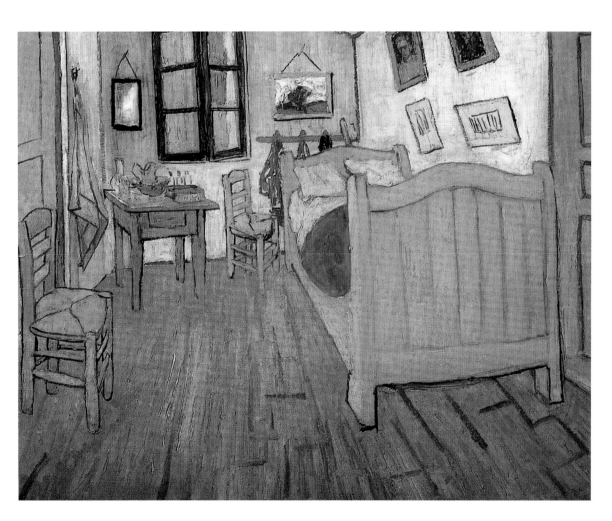

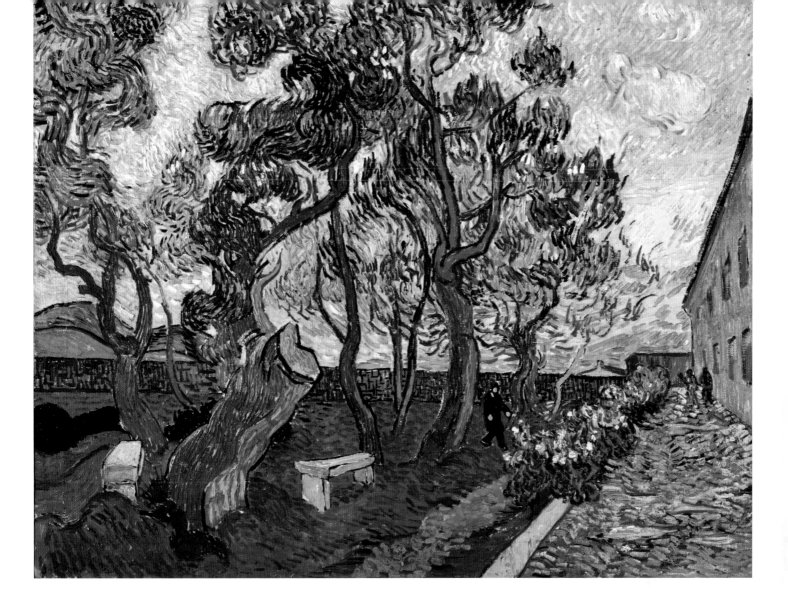

This famous painting is of the garden of the hospital where Van Gogh placed himself in order to be under the care of his doctor. While there he continued to paint, although his paints were confiscated on occasion – during the worst times of his illness he would try to eat them, which could have poisoned him.

Writing to Emile Bernard about this painting, Van Gogh commented on the power of red ochre and green darkened with grey or black. He likened this combination of colours to the 'black-red' anguish from which many of the patients at the hospital suffered.

This is probably a worked-up version of an original painted on the spot; we can deduce this from the care with which the brushstrokes are placed and the systematic use of colour. The composition is very well set out, without the annoying oddities that sometimes appear in an outdoor painting. Despite its overall dark accent, with the ruddy streaks of the setting sun in the background and the use of coloured marks mixing and contrasting close to one another, the final result is neither overbearing nor depressing. The rich hot red soil and the light streaks in the sky produce a strong, solid-looking landscape.

The Garden of Saint-Paul Hospital
St-Rémy, 1889

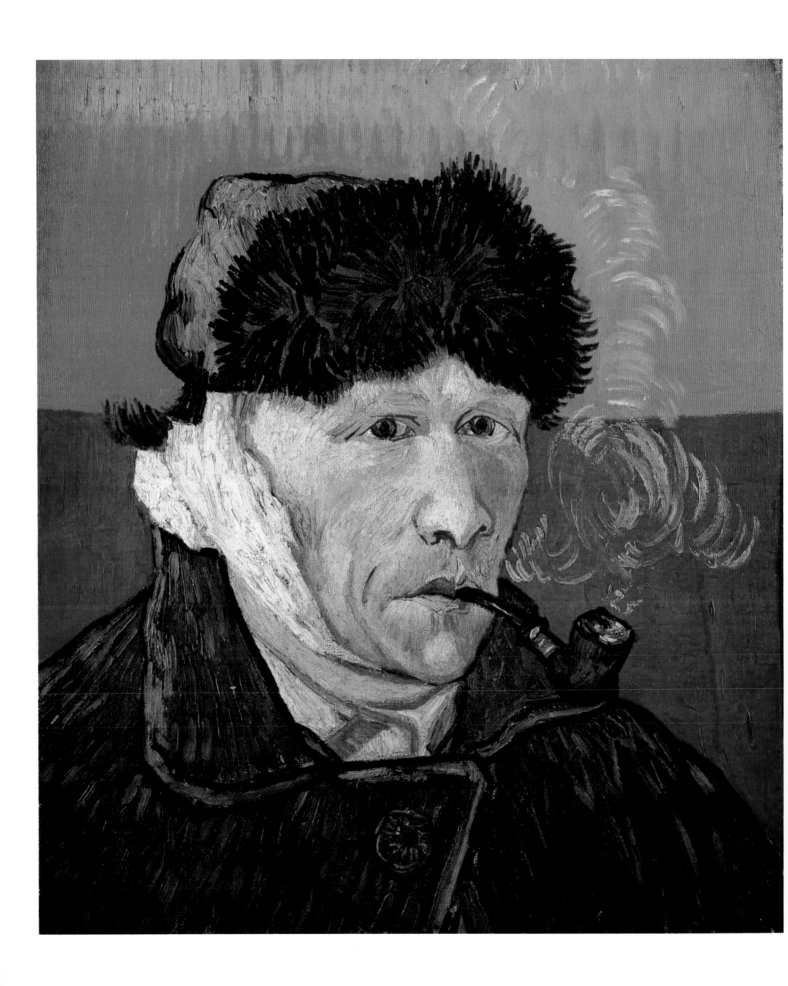

Self-Portrait with a Bandaged Ear and Pipe
Arles, 1889

This self-portrait was painted soon after Van Gogh's break with Gauguin and his self-mutilation episode and shows his gaunt features after leaving the asylum. The hat hides his shaven head but leaves most of the bandage on his injured ear exposed. Writing just before he left the hospital, Van Gogh appeared quite detached regarding the situation, as the following extracts from his letters demonstrate: 'I shall stay here at the hospital for a few days more, then I think I can count on returning to the house very quietly.'

Later he wrote: 'I assure you that some days in the hospital were very interesting, and perhaps it is from the sick that one learns to live. I hope I have just simply had an artist's fit . . .

'It astonishes me already when I compare my condition today with what it was a month ago . . . I knew . . . that one could fracture one's legs and arms and recover afterwards, but I did not know that you could fracture the brain in your head and recover from that too . . . Let me go on quietly with my work; if it is that of a madman, well, so much the worse. I can't help it . . . And if we are a bit mad what of it? Perhaps someday everyone will have neurosis . . .

'Instead of eating enough . . . I kept myself going on coffee and alcohol. I admit all that, but all the same it is true that to attain the high yellow note that I attained last summer, I really had to be pretty well keyed up . . . I have been in a hole all my life, and my mental condition is not only vague now, but has always been so, so that whatever is done for me, I cannot think things out so as to balance my life. Where I have to follow a rule, as here in the hospital, I feel at peace.'

This self-portrait shows that despite his difficult circumstances and mental instability Van Gogh was able to produce an extremely powerful painting, with humanity in the eyes and a certain playfulness in the colour scheme. He was still able to respond to the world in a controlled way, but he said prophetically, 'I shall always be cracked.'

6
OUTDOOR IDYLLS

Idyllic landscapes are usually thought of as those where trees, flowers, a sense of space and the gentle sky overhead combine to convey a general feeling of delight in the natural world. We know that Van Gogh spent a great deal of his boyhood wandering the woods and heathland surrounding his home. An awkward child, he felt happier away from the busy parsonage.

When he reached adulthood, Van Gogh's response to the power of nature found its best outlet in his art. While he was profoundly moved by the elements and by the sheer grandeur of some places, he believed a landscape worked on by men and women was more beautiful than the wilderness. He compared his task of painting to 'ploughing my canvases as they do in the fields'.

Many of Van Gogh's idylls were located in enclosed gardens, often with an abundance of flowers. Drawn to a mixture of buildings and vegetation, he would select views of towns or small rural settlements set in a landscape with sky, hills and trees. Even as a young man, far away from home, he had stored such images in his inner eye: '. . . chestnut trees with their burden of yellow leaves and the bright blue sky, and through the tops of those trees the part of Richmond that lies on the hill, the houses with their red roofs . . . and green gardens . . . the great grey bridge with the tall poplars on either side.'

He revelled in the variety of shapes among the wild trees of Provence as well as the carefully pruned examples in the parks, gardens and allotments around Paris. His great delight was the cypress tree, which he thought 'as beautiful of line and proportion as an Egyptian obelisk'.

Finally, for Van Gogh there was the more abstract idyll of tranquillity, a quality he sought constantly in order to produce his paintings unimpeded by anxiety: 'Of course my moods change but the average is serenity. I have a firm faith in art . . . a powerful stream which carries a man to harbour.'

Van Gogh's painting of this avenue lined with Roman sarcophagi was done in autumn, while Gauguin was still in Arles. Red and yellow leaves are scattered across the path, against which the figures are silhouetted. The burning colours of the pathway and the trees set against a blue sky make a glowing statement of autumn in the Midi region of France. The contrast of the sky, tree trunks and tombs with the flaming autumn leaves produces a potent image of nature in the southern climate that had so transformed Van Gogh's palette and techniques.

Allée des Alyscamps
Arles, 1888

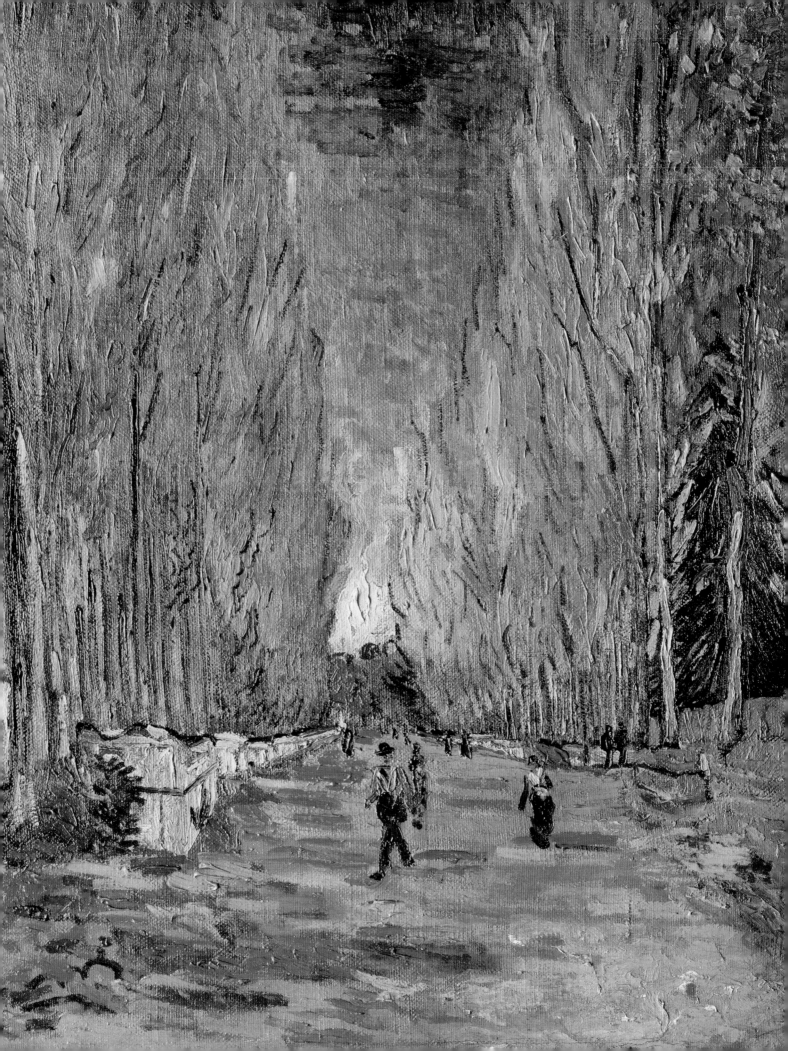

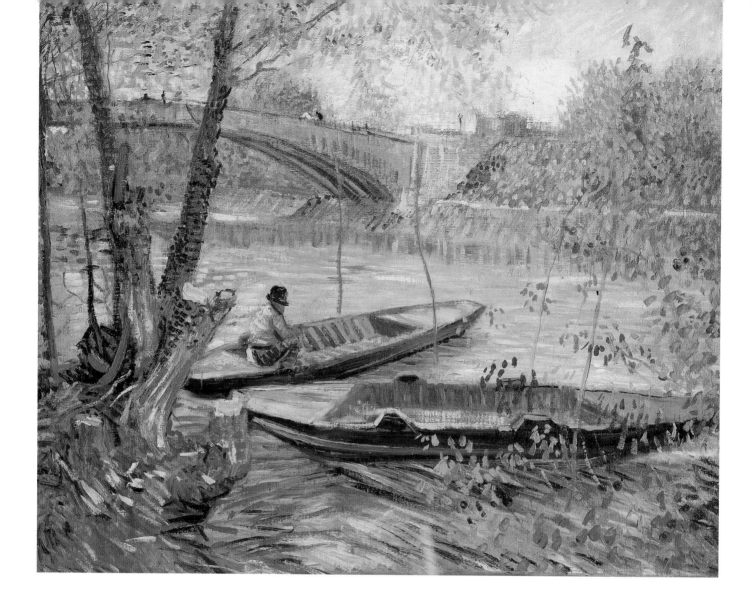

Van Gogh's exploration of the Impressionists' method of painting became highly effective in a very short time. This typical Impressionist scene of a fisherman in his punt on the Seine was painted while Van Gogh was in Paris, where he was greatly influenced by contemporary artists.

The picture is very much of the type painted by the Impressionists in the previous decade. It has all the freshness of Renoir and Pissarro, with light, bright colours and an airy atmosphere emphasized by the feathery leaves on the trees and the combination of blue and yellow contrasts in the water and background. The contrast between the arch of the bridge and the verticals of the tree trunks holds the whole design together. The boats float across the lower half of the picture providing movement, and the soft, airy background gives depth. *Fishing in Spring* is a first-rate artistic endeavour by a painter relatively new to this style.

Fishing in Spring
Paris, 1887

Edge of a Wheatfield with Poppies and a Lark
Paris, 1887

During his stay in Paris, Van Gogh often visited the local countryside to paint landscapes, where he was able to work on lightening his palette at the same time as he practised Impressionist techniques. His notes from this period mention his artist's appreciation for the colour yellow, which at Arles and later on played such a large part in his palette.

Van Gogh loved the countryside and nature. This picture shows his appreciation of the movement of the wind in the wheat, the clouds overhead and a lark rising from the ground. It is mostly a palette of yellows and blues, with a yellowish green and ochre to balance out the tones. There are a few very dark marks and a sprinkling of red poppies among the stalks of wheat. Van Gogh used a simple design of three horizontal layers, with the sky taking up half the picture and the wheat more than a quarter of the remainder. Small strokes of strong colour have been brushed thickly as stubble in the foreground and smudged softly as clouds, giving a textural contrast to the long stalks of wheat with ears painted in small flicks of paint across the top of the crop band.

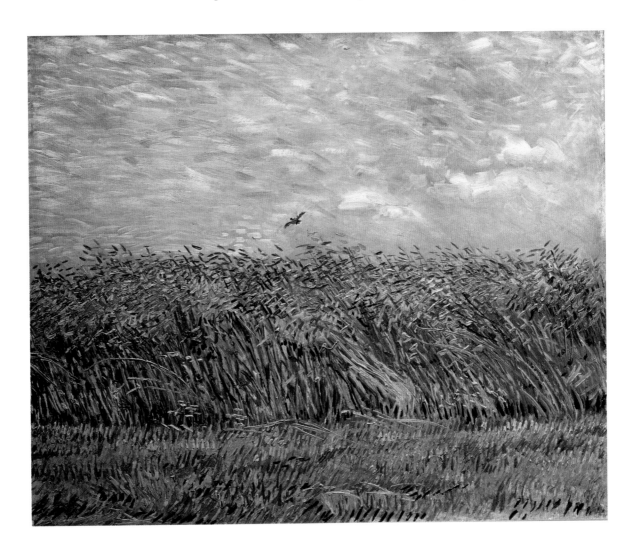

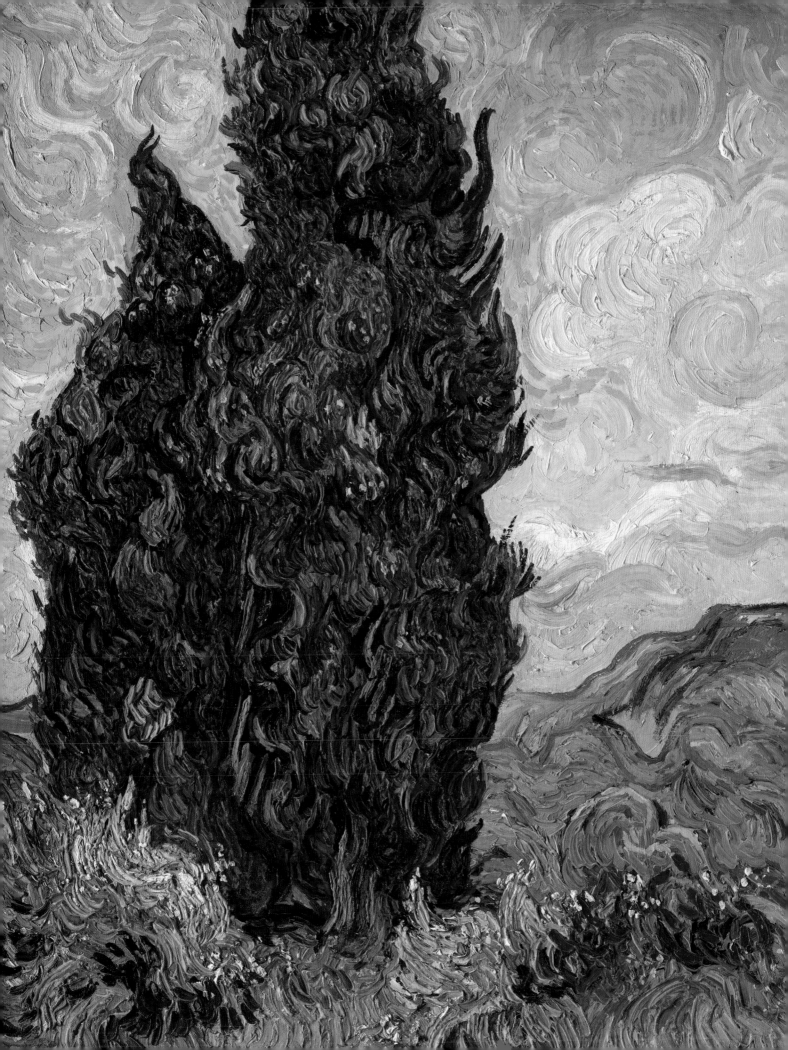

Cypresses
St-Rémy, 1889

Van Gogh made vigorous studies of the cypresses near St-Rémy before he produced this painting, with its view across the landscape to the mountains in the distance. He has taken the natural curl and sweep of the cypress trees and increased their undulations to create a flame-like flicker of dark tree shapes that seem to burn into the viewer's vision. As they are placed in the yellow and blue landscape of the Midi region, the contrast makes their dark shape potent, almost mesmerizing. Van Gogh wrote, 'The cypresses are always occupying my thoughts, I should like to make something of them, like the canvases of the sunflowers, because it astonishes me that they have not yet been done as I see them . . . the green has such a quality of distinction. It is a splash of black in a sunny landscape, but it is one of the most interesting black notes, and the most difficult to hit off exactly that I can imagine.'

There is no doubt that Van Gogh's cypress trees writhe with vigour, and no one who paints cypresses today can help but be influenced by his view of their static turbulence. In this picture the sky above and landscape below echo the movement of the cypresses in the brushstrokes of the artist.

This detailed painting of wheat stalks poking sentinel-straight up into the sky, with a mass of red poppies carpeting the foreground, has a low viewpoint and must have been painted as Van Gogh sat on the ground or worked from the lower level of a ditch. The distant tree line is softened to a smoky blue against a milky blue sky – evidently a slightly overcast June day in the Midi, with streaks of sunlit ground showing in the distance. Van Gogh had painted pictures with this central horizon and low viewpoint before in order to show the abundance of the lush fields of green wheat and flowers under the southern sky.

Green Ears of Wheat
Arles, 1888

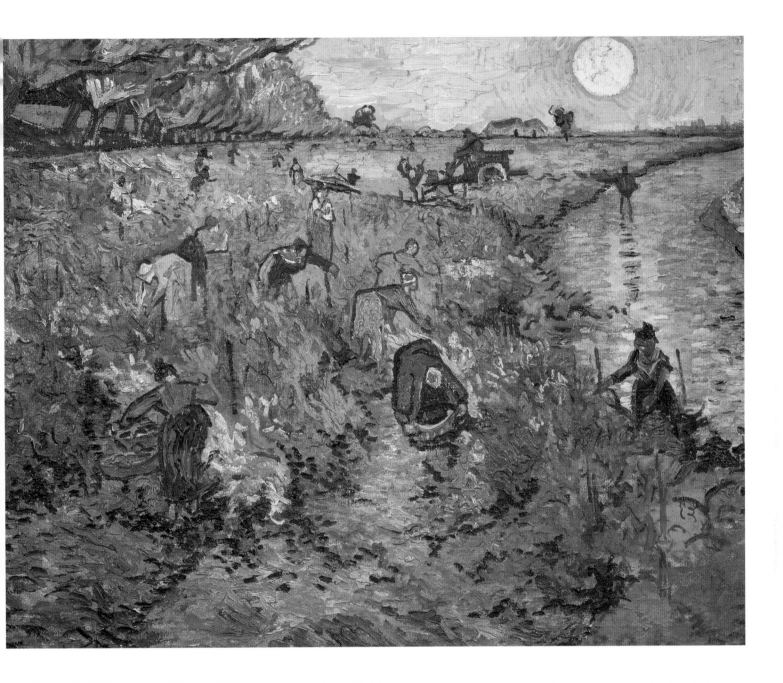

The Red Vineyard
Arles, 1888

'What is beautiful in the south are the vineyards, but they are in the flat country or the hillsides,' Van Gogh wrote to his mother. 'I have seen some, and even sent a picture to Theo in which the vineyard was quite purple, fire-red, and yellow and green and violet, like the Virginia creeper in Holland. I like to see a vineyard as much as a wheatfield. Then the hills full of thyme and other aromatic plants are very nice here, and because of the clearness of the air, from the heights one can see so much further than at home.'

This rich and potent red, yellow and blue painting gives us a view of Provence with the sun either rising or setting and crowds of peasant farmers harvesting the grape crop from the vineyard. The blue cast of the figures sets them sharply against the red leaves of the vines, and the stream alongside, reflecting the yellow sunlight, balances the blue tree line on the other side. It is a scene of industry and fruitfulness, wonderfully crafted by Van Gogh.

This strange and rather unsettling painting, which looks like a sketch of an idea rather than a complete work, has a dream-like quality with its two figures, one gesticulating, walking through groves of olive trees with the hint of hills and cypresses in the background. The sky is lit by the setting sun, with a large, pale crescent moon dominating the space. It resembles an illustration for a story and was probably painted from memory when Van Gogh was in hospital in St-Rémy.

The pale area in the foreground and the bright sky are good evocations of dusk, but can be seen as a vision of Van Gogh's state of mind rather than what he directly observed from nature. The painting is schematic in its rendering of trees, figures and distant hills. It is an interesting but unresolved work.

Landscape with Couple Walking and Crescent Moon
St-Rémy, 1889

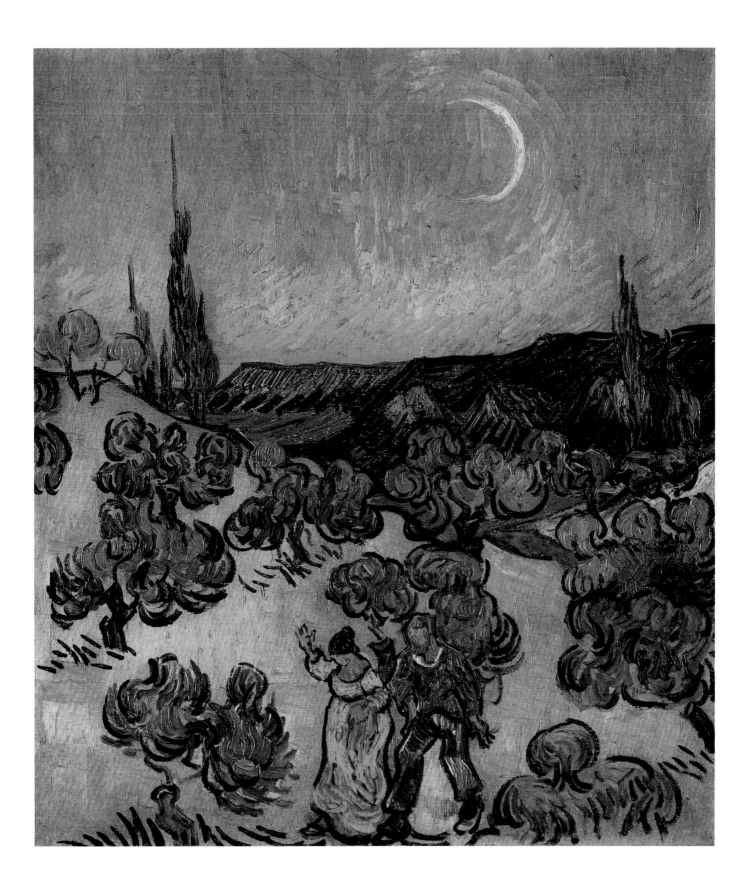

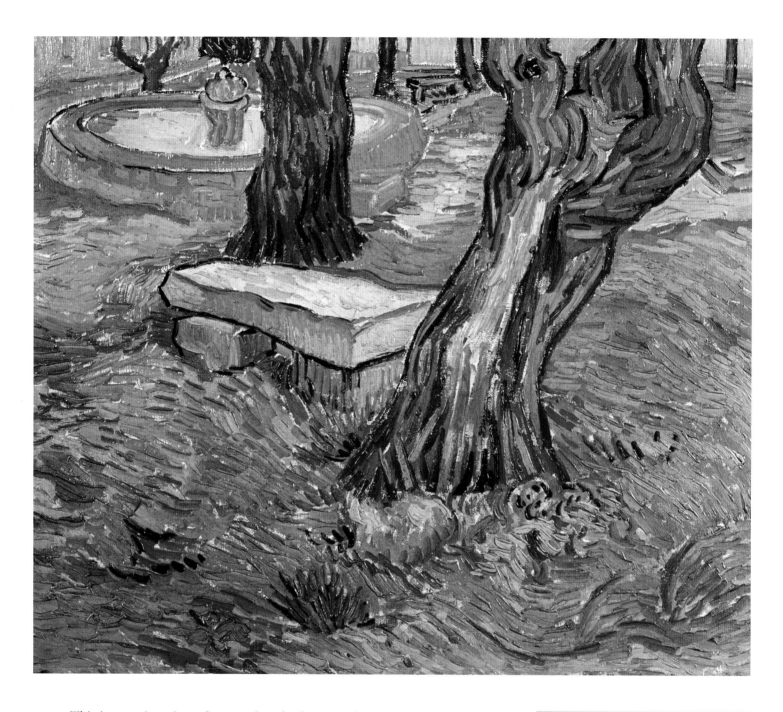

This interesting view of a stone bench, the stone fountain behind and the cut-off trunks of trees across the centre was produced during Van Gogh's time in the asylum at St-Rémy. It is remarkable, given Van Gogh's illness, that he was able to produce paintings that give little or no hint of his disturbed state of mind: this is a very peaceful piece of work, yet strong and powerful. The warm colours and strong directional brushstrokes make this composition a substantial statement of space and solidity.

The Stone Bench in the Garden of Saint-Paul Hospital
St-Rémy, 1889

Field with Poppies
Auvers-sur-Oise, 1890

In this painting, Van Gogh has used a stripped-down Impressionist technique that concentrates on expressing the mood of the scene as much as the light. The sky consists of deep blue and white brushstrokes, which sometimes mix and produce an intermediate blue tone. The trees stand out as dark green trunks against this sky and the far-off hills and hedges are a strong, fresh green. The closer foreground is painted with green and ochre colours, mixed to produce a warmer green background, and across this are spattered and massed hundreds of bright red poppy heads, mostly painted with one dab of the brush. Occasionally a dark stalk penetrates the blanket of poppy petals but mostly it is the strong red flower heads that hold the eye. They have a rich, romantic quality but are also rather sinister, like blood spattered across the field. One month after this was painted, while walking in fields like these, Van Gogh shot himself.

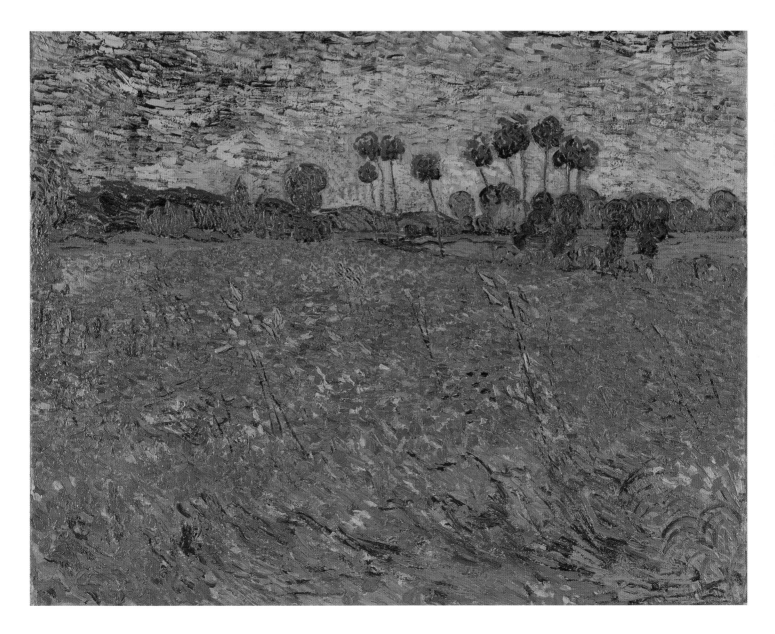

This extended landscape, with a reaper in the field and a carriage on the road, is full of activity and was painted in the final year of Van Gogh's life. Across the horizon, where the blue sky, put in with short brushstrokes, meets the land, a dark goods train travels across the picture, leaving a trail of pale clouds of smoke in its track. The plantation of trees anchors the left upper corner of the flat land, and the red-roofed houses in the middle right of the picture give a strong focal point to help place the low-lying foreground and the distant patchwork of fields. The whole picture is a careful composition that is unlikely to have been painted directly from life but probably from a drawing already in existence. The viewpoint is very high, looking down on the foreground, and although everything looks naturalistic enough the painting of each part is very much reduced to a systematic set of brushstrokes. This painting includes many of Van Gogh's favourite motifs: a field enclosed by a wall, a reaper, a carriage on the road and a train in the distance.

Landscape with Carriage and Train in the Background
Auvers-sur-Oise, 1890

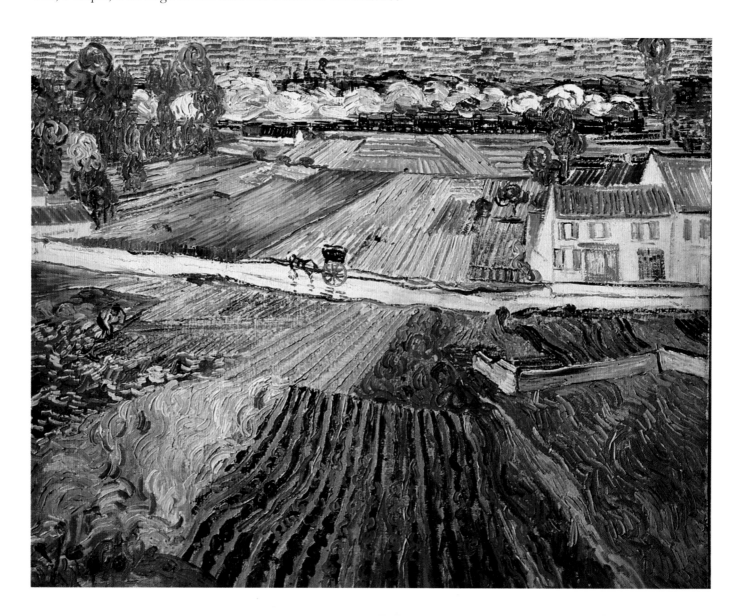

Landscape at Auvers in the Rain
Auvers-sur-Oise, 1890

This unusual landscape was one of Van Gogh's very last pieces of work. The yellow wheatfields, the blue-grey sky, the blue-green trees and hedges and the pallid roofs of the houses look rather sad after the magnificent southern landscapes painted in the Midi region.

On top of the mostly horizontal bands of colour and texture there are slashing strokes of paint, dry-brushed in grey, blue and black, criss-crossing the whole painting like a screen. This veil of rain makes the whole scene gloomy, and the mood takes another downward turn thanks to the black crows winging their way heavily across the tops of the crops in the foreground. The entire scene is imbued with a sad, damp feel, such as you might find on a dreary autumn day, but without the colours of autumn. Maybe it is just the effect of a rainy day in July, the middle of summer, rather than an intimation of Van Gogh's impending death.

7
PEOPLE UP CLOSE

Van Gogh's portraits have an immediate appeal that lies in the rich colour contrasts he used for flesh and clothing and in the dramatic delineation of the sitters' features, which he tended to almost carve out of the paint. There is something engaging too in the way that he placed some heads against a particular background, as in the case of the postman Joseph Roulin and his flowery wallpaper. Rather than using a darker tone for the side of a face that was turned away from the light, Van Gogh painted it close in tone to the lighter side but in a significantly different colour. He became an expert at playing cool colours against warm and was not afraid of putting a bold outline to features, which he achieved without a harsh effect.

In Antwerp, Van Gogh's portraits, like most of his work, had followed the style of the old Dutch masters, using extreme contrast in tonal values and a narrow colour range. Once in Paris, where his palette lightened, he explored the theories and methods of the Impressionists and Pointillists. This examination of colour and the resultant extreme palette remained a major preoccupation of Van Gogh's and helped him towards the essentially modern portraits of his final years.

Looking at Van Gogh's portraits, viewers sense a response from the face in the frame. Perhaps because his own emotions were so near the surface, Van Gogh knew how to evoke the vulnerability, the innocence and also the more guarded characteristics of his subjects. His brushstrokes convey the body language of the sitter and suggest how he or she might be reacting to the situation.

Wherever he lived, Van Gogh set about portraying his neighbours. His eccentricities and rough manners concealed a deep concern for the human condition and an instinct for conviviality. As his friend, the painter Emile Bernard, wrote after his death: 'People who had known him a little . . . liked him because he was so good-hearted, so human.'

Père Tanguy was the avuncular Paris art supplier and dealer who was a champion of unrecognized artists, often allowing them supplies in return for a painting. Here he is set against a background of Japanese prints, or at least Van Gogh's versions of them. The handling of the colour is quite light and his features are painted with an almost childlike reduction of shapes, but without losing the solid dimensional quality of the round head and the strong, clasped hands. It is interesting to note the bright vermilion outline around the seated figure, which helps to separate it from the background.

Portrait of Père Tanguy
Paris, 1887

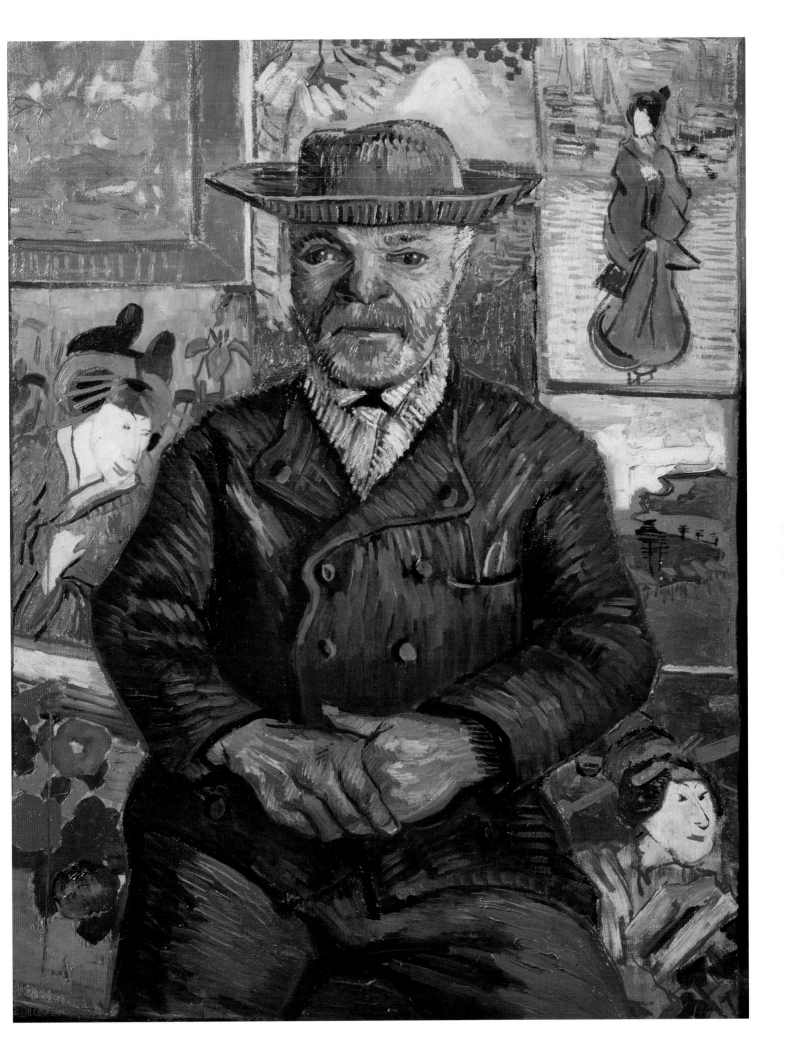

This is one of Van Gogh's most extraordinary portraits, because it almost looks like a regression to an amateur style. However, the one big difference is the astounding range of colour, which previously had not been seen so clearly in his Paris work. It is almost as if this is a composition of primary colours, with the drawing merely a peg on which to hang them. It is likely that at this point Van Gogh threw away the Impressionists' system of colour analysis in order to paint with strong colours, in the raw.

The exotic costume with its shouting pinks and reds and the way Van Gogh has outlined some of the features in pure, strong colour gives a brilliant poster-like look to the figure. It is as if one of his beloved Japanese prints has been saturated with the brightest colours on the chart. Even the background has the effect of pushing the colour forward, and the brilliant yellow is offset by the multi-coloured striped border. The blue chair seems specially chosen to jump against the yellows and reds of the background and the figure. This is an amazing example of colour used at its strongest and most hectic, and it has produced a very potent painting in what is simply a rather cheerful way.

The model for this portrait was Agostina Segatori, from Naples, who ran the Café du Tambourin in Paris, which Van Gogh and his friends frequented. Apparently she also sat as a model for the famous French artist Corot, who in many ways anticipated the Impressionists' methods. Perhaps Van Gogh was aware of this; he brought the movement full circle by painting her in a way that had gone beyond Impressionism.

L'Italienne
Paris, 1887

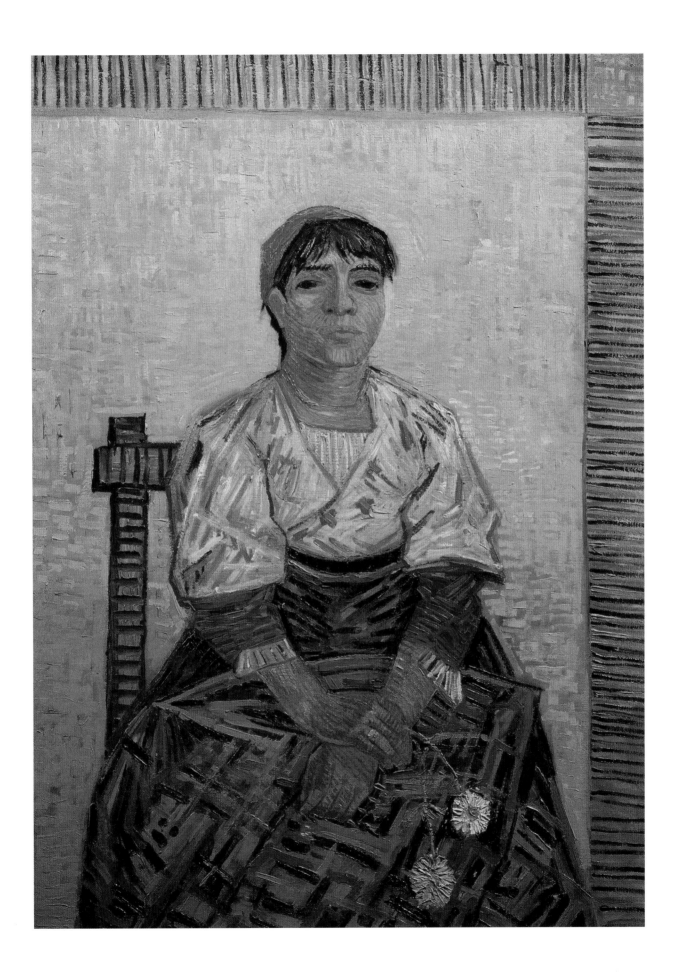

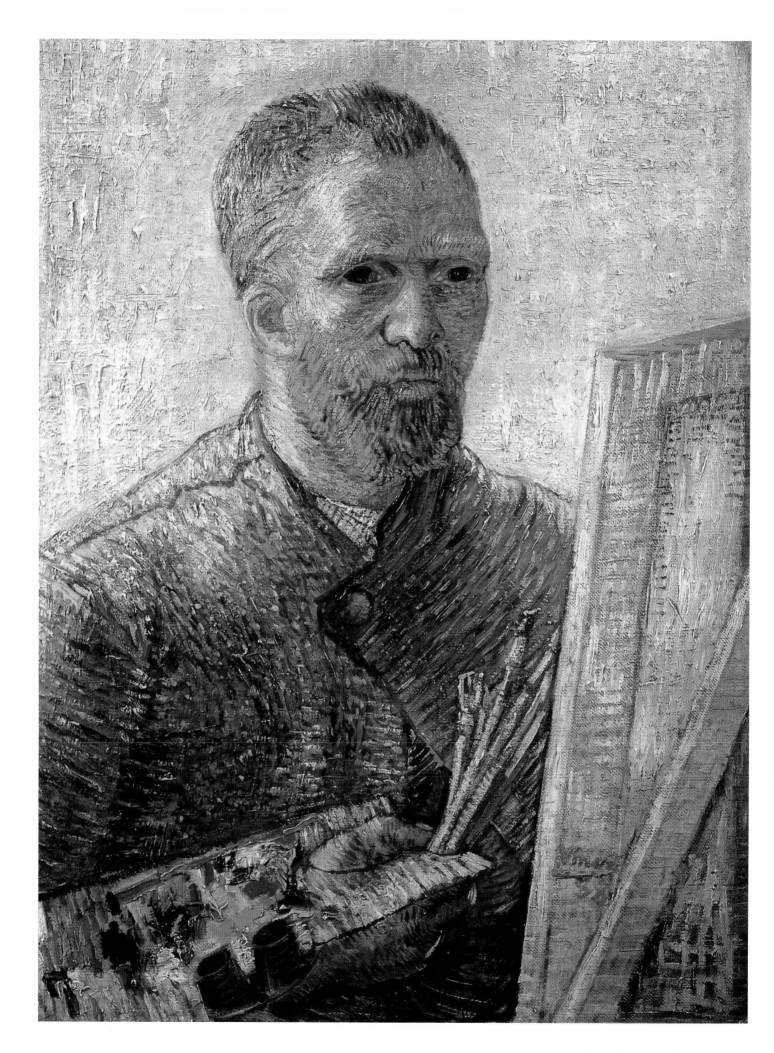

Self-Portrait as a Painter
Paris, 1888

While he was in Paris, trying to think of ways to earn a living as a painter, Van Gogh produced several self-portraits with the idea that if he could display some good ones this might generate some work. He should have taken as much advantage as possible of the close connections that Paris could have made for him, but unfortunately he managed to quarrel with many of his friends and acquaintances, which affected his financial situation. He was well thought of by the younger artists of the time, but that did not help to increase his income.

This is one of Van Gogh's last self-portraits before he moved to Arles. He described it to his sister as a 'pink-grey countenance with green eyes, ashen hair, lines in the forehead and around the mouth, stiff, wooden, an extremely red beard, quite desperate and sad'. The mask of the face registers nothing; only the staring eyes suggest that the face is inhabited by a person. The paint is handled in a fairly Impressionistic way, with the texture of the painted marks helping to show the contours of the face. This portrait is interesting in so far as it depicts Van Gogh as an artist, with easel, palette and a clutch of brushes. It is almost as though he is trying to establish his function as a professional artist through this painting.

Van Gogh's self-portraits are particularly soul-baring, giving us a clear indication of his ideas about his work: 'Painted portraits have a life of their own, something that comes from the roots of the painter's soul.'

La Mousmé
Arles, 1888

When Van Gogh moved to Arles, he was immediately enchanted by the whole atmosphere of the Midi region of France. He was convinced that here was the place where 'the painter of the future will be a colourist such as has never existed'. Describing one of his portraits, he said, 'I imagine the man . . . surrounded by the whole Midi. Hence the orange colours flashing like lightning.' The volume of his work became profuse, and he realized that other artists thought he painted too fast. Van Gogh did not see speed as a problem: 'Quick work doesn't mean less serious work, it depends on one's self-confidence and experience. Is it not emotion, the sincerity of one's feelings for nature, that drives us? . . . the emotions are so strong that one works without knowing one works, when sometimes the strokes come with a continuity and a coherence like words in a speech or a letter . . . In the south, one's senses get keener . . . one's brain clearer.'

This painting was produced in the summer of Van Gogh's first year in Arles, and the girl is one of the Arlésiennes who sat for him. In a letter to his brother Theo, Van Gogh wrote, 'A mousmé is a Japanese girl – Provençale in this case – twelve to fourteen years old.' He has chosen a simple pose; the girl's right hand rests on the arm of the chair and the left holds a white flower in her lap. The skirt is painted as an almost flat blue shape, studded with orange-vermilion spots; her jacket is a striped blue and vermilion fitted garment with round red buttons and a hint of white collar at the top; and her hair is tied back with a red ribbon, all set against a light blue-green background. The handling of the face is unusual, more delicate, as though Van Gogh was trying not to make his brushstrokes too strong for the shape of her face. The portrait looks highly simplified and systematic, as though there was no time for second thoughts. Possibly the model wouldn't pose for long, so Van Gogh had to finish this work in one sitting.

Second-Lieutenant Milliet became a good friend of Van Gogh while he was in Arles. Van Gogh wrote about him in letters on his luck in love affairs: 'Milliet is lucky, he has as many Arlésiennes as he wants; but then he cannot paint them, and if he were a painter he would not get them. I must bide my time without rushing things.' Van Gogh's point – a rather sad conclusion – was that you cannot give your heart to painting and to a girl: it was one or the other.

Van Gogh has certainly captured the élan of the French military spirit in the painting of this handsome young officer. His impressive whiskers and small goatee, still in the style of Louis Napoleon III, his gleaming campaign medal and the rakish red-topped kepi and black patrol jacket have such strong identity that it would be easy to miss the rather sensitive look on the young man's face. Everything in this painting is bold, simple and ardent, including the technique of thick, well-modulated brush-strokes.

The background of blue-green with the regimental symbol of the Zouave Regiment, the crescent and star, make this a strong contender for a proper military portrait. However, despite having painted several soldiers, Van Gogh was still unable to sell or obtain commissions for portraits of this type.

Milliet said of Van Gogh, 'a strange fellow, impulsive like someone who has lived a long time in the sun of the desert . . . a charming companion when he knew what he wanted, which did not happen every day. We would frequently take beautiful walks through the countryside around Arles and out there both of us made a great many sketches. Sometimes he put his easel up and began to smear away with paints. And that, well, that was no good. This fellow who had great taste and talent for drawing became abnormal as soon as he touched a brush . . . he painted too broadly, paid no attention to details, did not draw first . . . he replaced drawing by colours.'

The Lover (Portrait of Lieutenant Milliet)
Arles, 1888

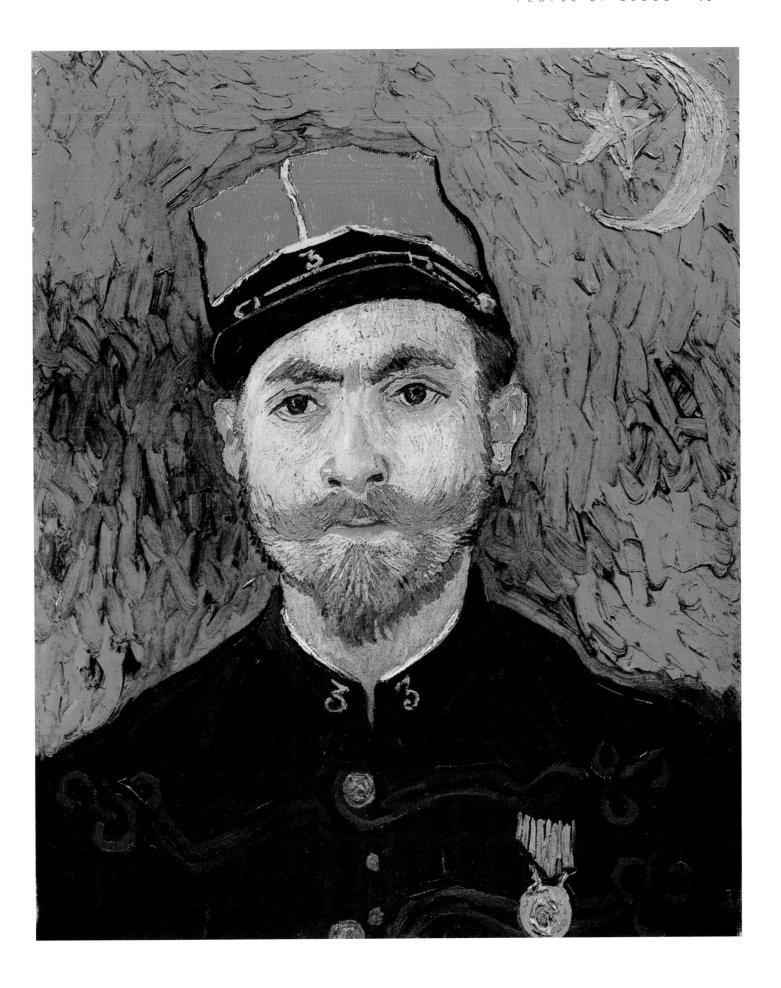

This remarkable portrait of an old peasant is a very positive statement of the colour combinations that Van Gogh was now interested in. The bright yellow, thickly painted straw hat and the sharply lined bright blue smock contrast splendidly with the bright orange background; the colour of the south as far as Van Gogh was concerned. The vermilion splashes on the undershirt and scarf act like a searchlight to draw attention to the remarkable weather-beaten face of Patience Escalier, with reflections lighting his nose and cheekbones under the deep ochre of his hat brim. The gnarled hands clasped below his stubbly grey beard show the hardship of his working life and resemble roots or the twisted branches of a tree.

In this painstaking portrait Van Gogh has encapsulated the spirit of the southern working population. Despite the slight traces of anxiety in the face it is generally peaceful, with an air of wisdom. This painting gives a very clear statement of the direction that Van Gogh's work was taking, away from the Impressionist background that he had been attracted to in Paris. No one had painted quite like this before.

Portrait of Patience Escalier
Arles, 1888

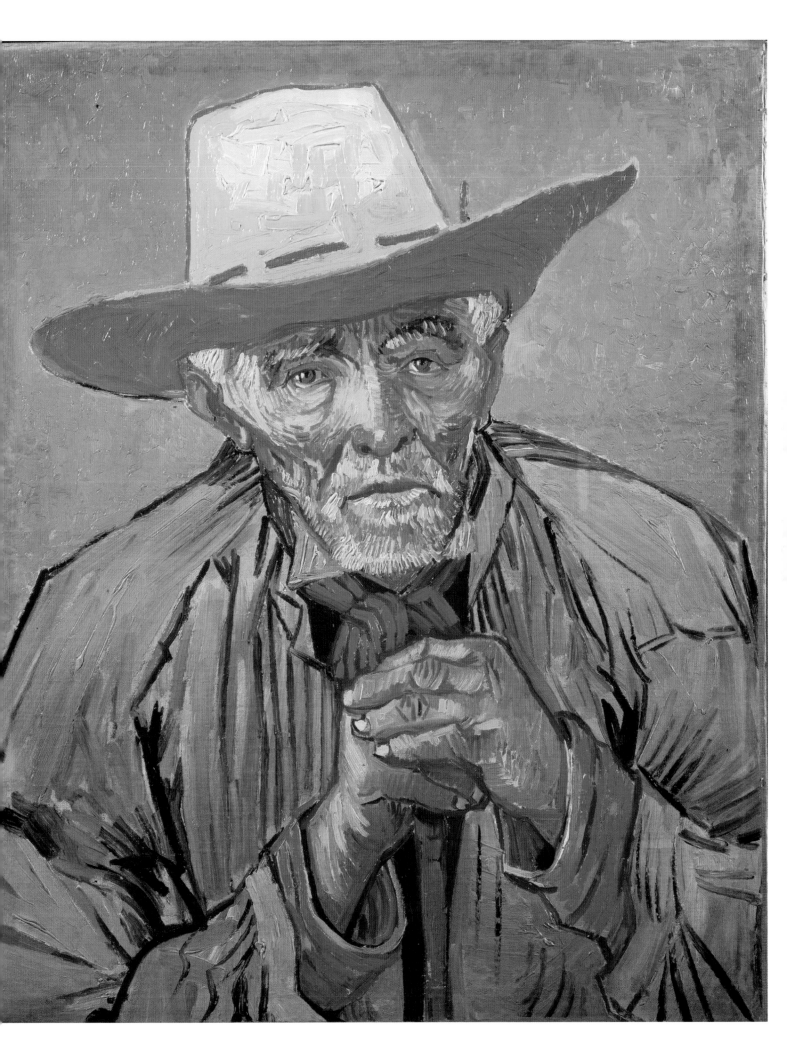

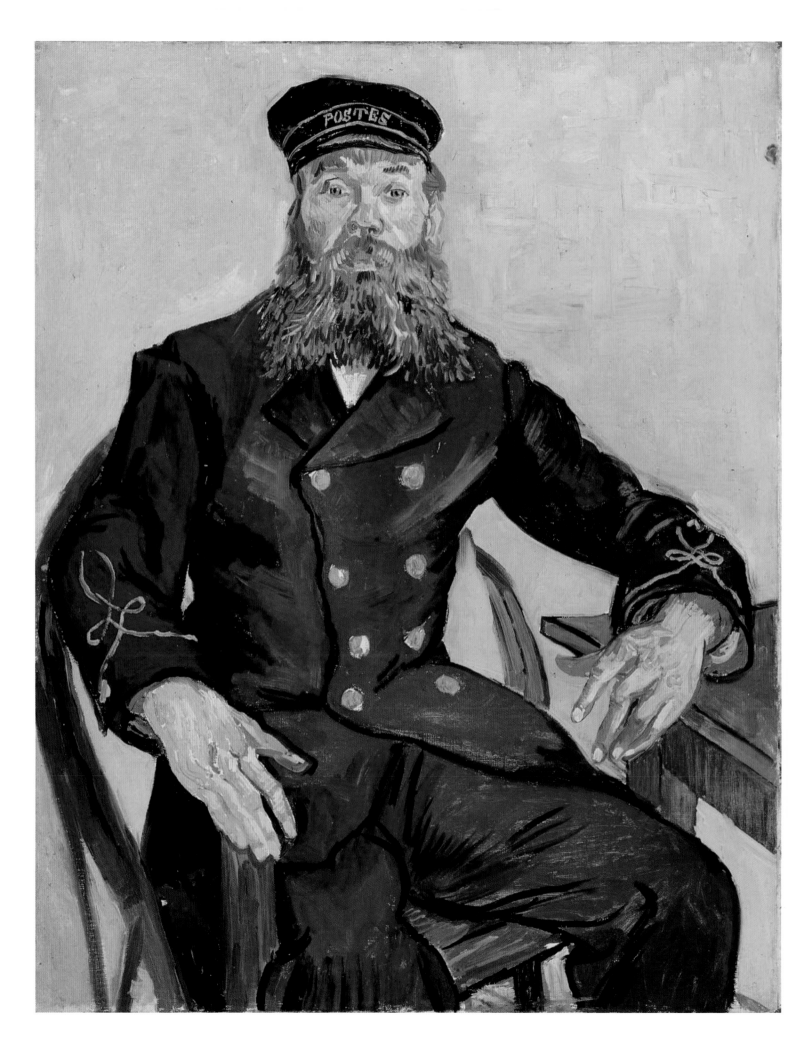

Portrait of the Postman Joseph Roulin
Arles, 1888

Joseph Roulin was the local postman, and he and all his family were friendly with Van Gogh. The family lived close to the Yellow House and Van Gogh decided that he would paint every one of them. He wrote of making portraits 'of an entire family, that of the postman, of whom I have earlier done a head: husband, wife, baby, and the little boy and the sixteen-year-old son, all types and truly French, although they look like Russians.'

In another letter he referred to his pace of work: 'Today again from seven o'clock in the morning till six in the evening I worked without stirring except to take some food a step or two away . . . I have no thought of fatigue, I shall do another picture this very night, and I shall bring it off.' It is not surprising that he could produce so many pictures in so short a time, nor indeed that he became ill.

When Van Gogh was allowed out of hospital after his crisis with Gauguin he wrote: 'I came out of the hospital with kind old Roulin, who had come to get me . . . Roulin, though he is not quite old enough to be like a father to me, nevertheless has a silent gravity and a tenderness for me such as an old soldier might have for a young one . . . a man who is neither embittered, nor sad, nor perfect nor happy, nor always irreproachably just. But a good soul and so wise and so full of feeling and so trustful.'

Joseph Roulin posed for Van Gogh six times. At the time of this portrait he was the proud father of a newborn daughter, and some of his cheerful pride shows in the painting.

Detail Although the brushmarks of loaded colour on the face of Joseph Roulin's portrait are vigorous and clearly to be seen, they are placed so carefully that the surface of the man's face is clearly defined and there is no impression that the marks are too strong for the face. The texture gives a lively effect to the quite precisely graded colours and tones – Van Gogh had meticulous artistic control, even if his brush strokes appear to lack it.

Van Gogh's series of portraits of the Roulin family included this painting of Joseph Roulin's youngest son, Camille, an eleven-year-old, whom he paints wearing a large floppy beret-style hat. The boy was probably pleased to sit as the rest of his family were being painted as well, and no doubt he would not have wanted to be left out. Even given Van Gogh's speed of painting, it was quite a feat to get the youngster to keep still long enough to get such a strong portrait.

The young inquisitive face, with bright blue eyes and a rather large nose, appears to be staring at something, as if in a dream – possibly because he had been sitting for so long or perhaps he was watching Van Gogh paint. The dashing brushwork of the hat and jacket are mirrored in slightly finer form on the features of the face, producing a soft-looking surface despite the obvious brushstrokes.

Portrait of Camille Roulin
Arles, 1888

Portrait of Armand Roulin
Arles, 1888

The portrait of Roulin's eldest son, Armand, is a sensitive picture of a young countryman endeavouring to display panache, with his jaunty hat and yellow jacket. The slightly uncertain look in his eyes and the wispy moustache barely disguising his soft mouth convey his youth. He looks as though he has put on his best clothes in order to make his portrait as impressive as possible, and Van Gogh has shown his temporary elegance without a hint of irony. The blue-green background makes a beautiful foil for the yellow coat and dark hat and conveys a touch of the freshness and hope surrounding the young man.

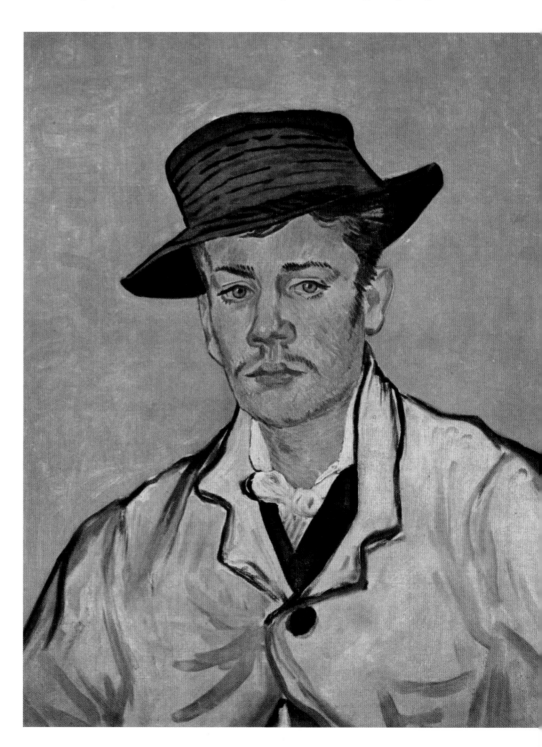

This is the wife of Joseph Roulin, mother of Armand, Camille and the family's newborn baby girl, with whom she was also painted. Van Gogh attempted several of these paintings at the same time and had quite a struggle to finish even one of them.

Van Gogh has been careful to bring the range of colours into very close harmony, without the sudden surprises of some of his more brilliantly coloured efforts. He seems to have taken his colour cue from the background wallpaper or curtain. The figure is heavily outlined, which helps to lift it out of the strongly patterned background, and the greens, greys, browns and red ochres of the figure are harmonized by keeping the tones close to each other. Van Gogh has given his sitter's head an almost spotlit upper half, showing up her red hair and giving a warm glow to her face, which looks surprisingly young in comparison to her workworn hands. She sits comfortably and patiently, waiting for the painting to be finished: one feels that her mind is not far from her family and their needs. The way Van Gogh has finely painted the surface of the face shows that he was keen to work the facets, dimensions and structure of the head in as smooth a way as possible. The face is a beautiful example of a much-loved matriarch: gentle, warm and unmarked by the stress of time.

La Berceuse (Augustine Roulin)
Arles, 1888

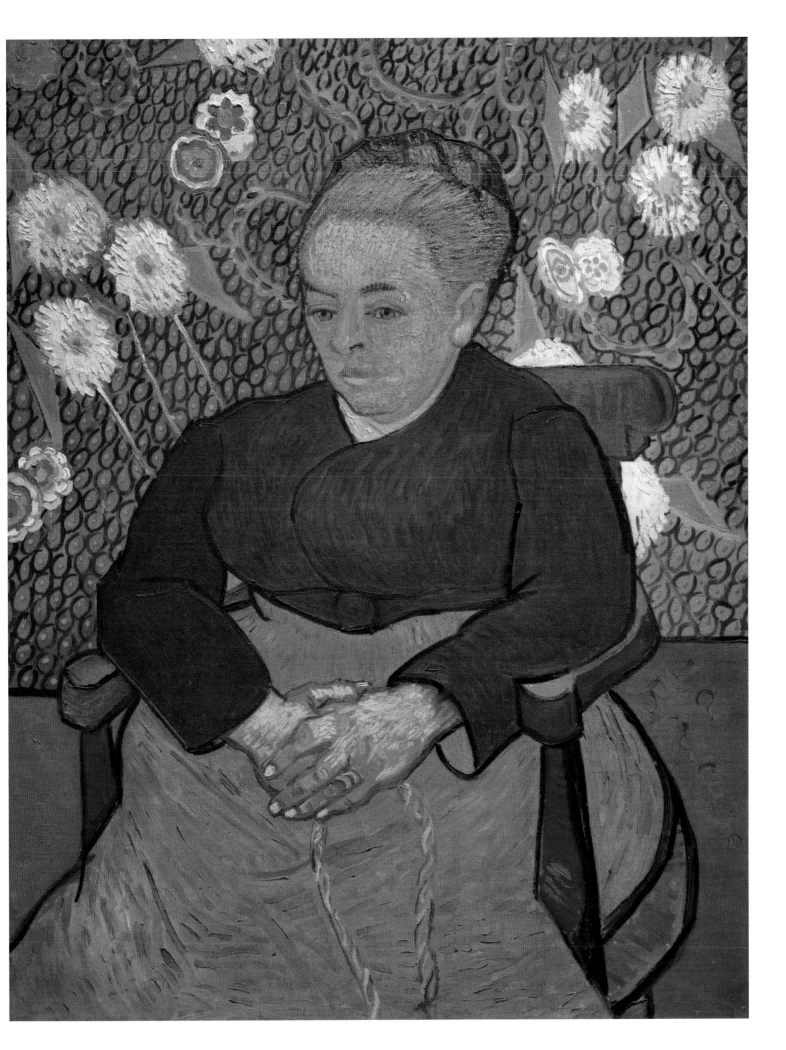

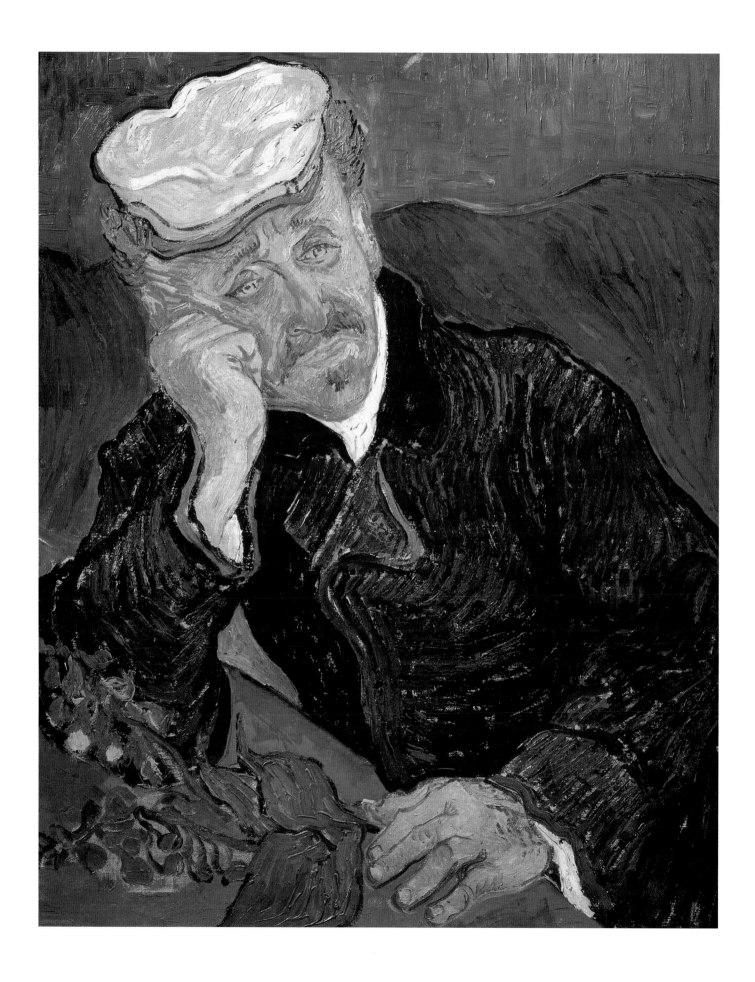

Portrait of Dr Gachet
Auvers-sur-Oise, 1890

Dr Paul Gachet was a physician and amateur painter, a friend of Monticelli and a collector of works by Cézanne, Pissarro and Renoir. Pissarro suggested to Theo, Van Gogh's brother, that the doctor keep an eye on Van Gogh while he lived near Paris so that Theo could visit him more easily. The doctor was obliging and encouraged Van Gogh in his work. Van Gogh felt he had found a true friend in Gachet. 'I have seen Dr Gachet, who gives me an impression of being rather eccentric, but his experience as a doctor must keep him balanced enough to combat the nervous trouble from which he certainly seems to me to be suffering at least as seriously as I . . . his house is full of black antiques, black, black, black . . . except for the Impressionist paintings mentioned. The impression I got of him was not unfavourable. When he spoke of Belgium and the days of the old painters, his grief-hardened face grew smiling again, and I think I shall go on being friends with him and that I shall do his portrait... this gentleman knows a good deal about painting, and he greatly likes mine; he encourages me very much, and two or three times a week he comes and visits me for a few hours to see what I am doing.'

Van Gogh said of this portrait, 'I painted Dr Gachet with an expression of melancholy, which would seem to look like a grimace to many who saw the canvas . . . with the broken-hearted expression of our time.'

On 27 July 1890 Van Gogh was lunching with the Gachets, when he suddenly got up from the table and left. That afternoon he shot himself. He lived for another day and a half, but when Theo spoke of trying to find a cure for him, his reply was 'La tristesse durera' ('the sadness will last forever'). He died from his wound in the arms of his brother.

8

STILL LIFE

Van Gogh is well known for his landscapes and portraits, but it is his still life paintings of sunflowers that really persist in the popular mind.

Painters often use still lifes as a recourse to expression when other subjects are unavailable, perhaps due to bad weather or the lack of a model. Also, when the mind is struggling for focus, executing a still life can be the quickest way to resolve the problem. It is not difficult to gather a few everyday objects together and arrange them, with some consideration for lighting and background, into an agreeable composition for painting. Many artists have made it their speciality and Van Gogh would have known the great 17th-century Dutch tradition of still-life painting from the works of such masters as Van Beyeren, Bosschaert and Snyders.

This section shows a range of Van Gogh's still lifes. They are selected from various periods of his life and vary quite obviously in quality and expertise. The one thing they have in common is sincerity and an intense interest in the materiality of the subject matter.

Van Gogh was quite adventurous in the choice of topics for his still lifes and although he never had much money to buy props, he seemed keen to try any combination of objects. Sometimes, substance and form was the main reason for the choice. He assembled a group of bird's nests in 1885: 'I am now busy painting still lifes of my bird's nests, four of which are finished; I think some people who are good observers of nature might like them because of the colours of the moss, the dry leaves and the grasses.'

Once he moved to Paris in 1886, Van Gogh's previously restrained Dutch palette was replaced by a stunning burst of colour. 'Just dash something down when you see a blank canvas staring at you.' This was the result of some tireless devotion to flower studies, as he tested the Impressionists' ground-breaking colour theories.

Van Gogh wanted the Yellow House at Arles to be decorated in 'a symphony of blue and yellow' to greet Gauguin when he came to live with him. He intended that the sunflower paintings should all be in Gauguin's room, framed in red-painted wood. A conventional still life of flowers in a vase can appear nicely decorative and somewhat lifeless, but here the vigour and power of the growth and the condensed sunlight in the orange and gold blooms cannot be seen as just an elegant adjunct to a drawing-room wall: they almost grab the viewer by the throat.

Sunflowers
Arles, 1888

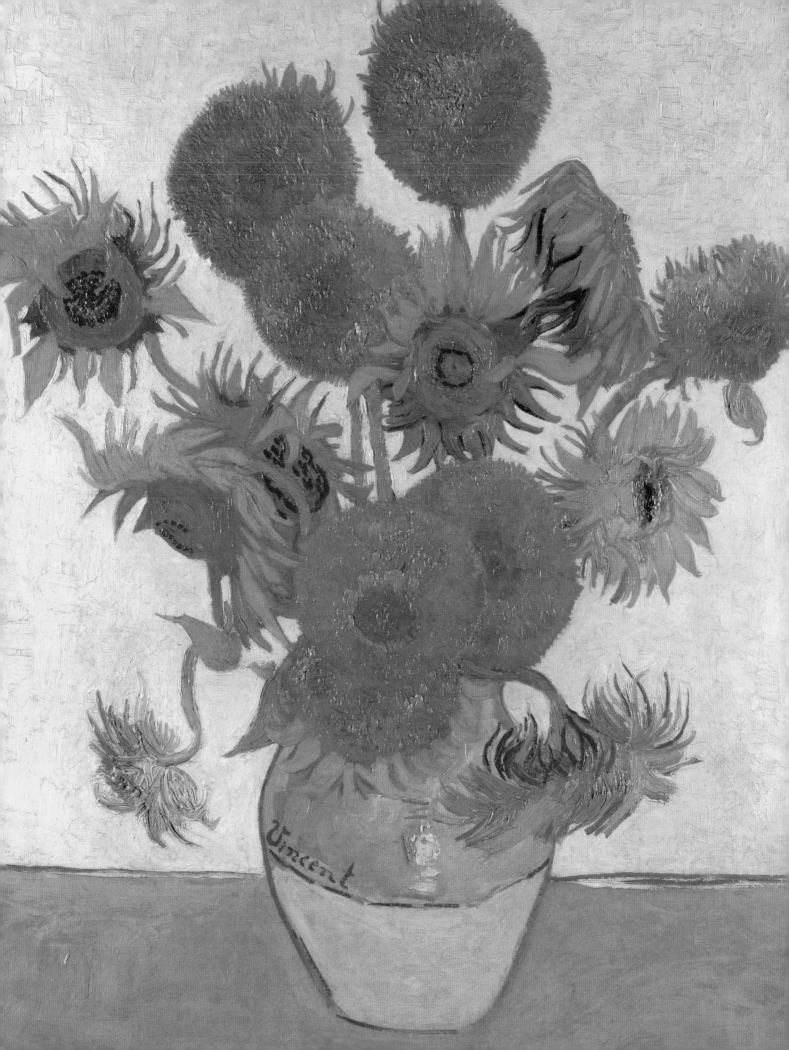

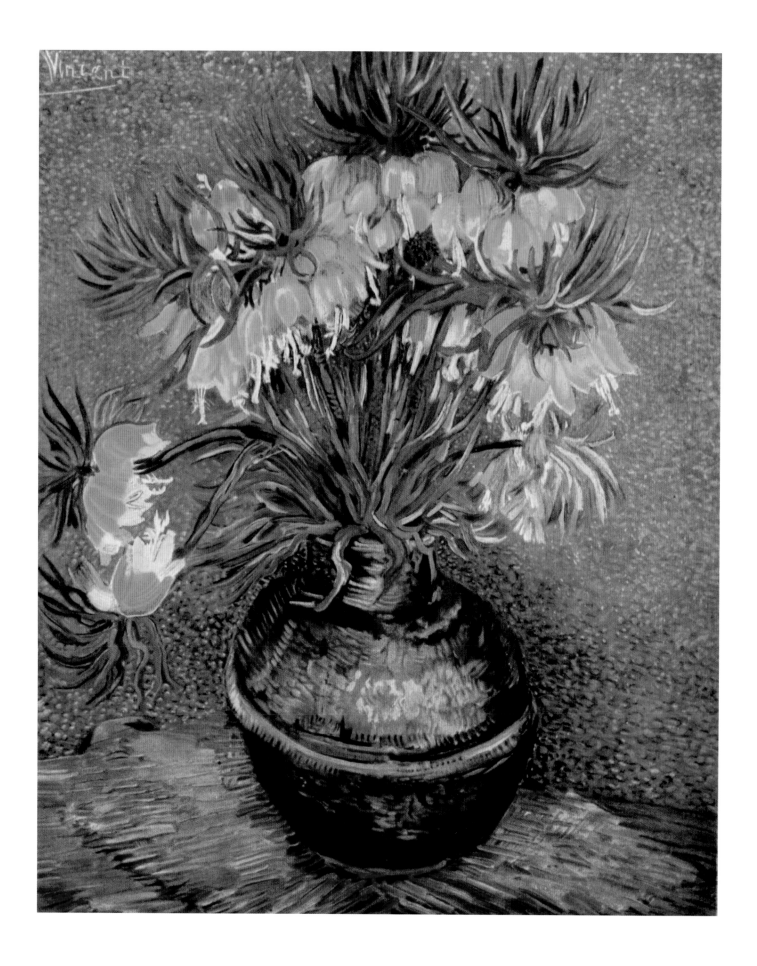

Crown Imperial Fritillaries in a Copper Vase
Paris, 1887

Some of the first signs of Van Gogh's attempt to lighten and brighten his palette are found in his paintings of flowers in vases. He was very impressed by the painter Adolphe Monticelli, who painted many colourful vases of flowers using thick, impasto paint and strong, even clashing, colour combinations. Monticelli's critics were very rude about his loose technique of painting, but Van Gogh disagreed. He admired his work and said of one of his pieces that Theo van Gogh bought, 'In terms of colour it is something of the first order.'

In this painting of orange-yellow fritillaries in a copper vase, on the corner of a table against a wall of blue, Van Gogh has attempted a very strong colour contrast, combining the complementary colours of orange and blue with green and only a little yellow to soften the blue. He did not take these contrasts as far as he did in his paintings in Arles, and the blue background is reduced with yellowish-white dots to stop it being too overwhelming. The strength of the bright copper vase gives a nice balance to the strong orange fritillaries, which are also slightly reduced in contrast by the darker green leaves next to them and the dark grey stems.

Although this is a considerable lightening of Van Gogh's palette from his Nuenen days, and a very powerful contrast in theory, the careful handling of the tonal values stops the jump in contrast that might have occurred. This is an interesting consideration of more traditional painting tonalities that holds his colour intensity in check.

This is an interesting variation on Van Gogh's usual tendency towards yellowish flowers; brilliant red, white and blue flowers, in a pale blue vase on a warm-coloured tablecloth, against a deep blue wall. Was this an attempt to show his appreciation of French culture with a patriotic bouquet, possibly finished for Bastille Day in July 1887? Its brightness shows how his progress in changing his colour values had progressed: the intensity of colour seems to increase in leaps and bounds until his culminating efforts in Arles. It is noticeable that although he retained a lighter and brighter palette after returning to the north again from Arles, his colours definitely began to show a cooler, more controlled range of tones. Perhaps he curbed his exuberance under the influence of 'polite' society once again.

Van Gogh was influenced by Adolphe Monticelli, who was well known for his highly coloured flower paintings, and this painting may have been a form of homage to Monticelli. He was also influenced by Henri Fantin-Latour, a masterly painter of flower pieces, whom Van Gogh called 'one of the most independent spirits of our time'.

Vase with Cornflowers and Poppies
Paris, 1887

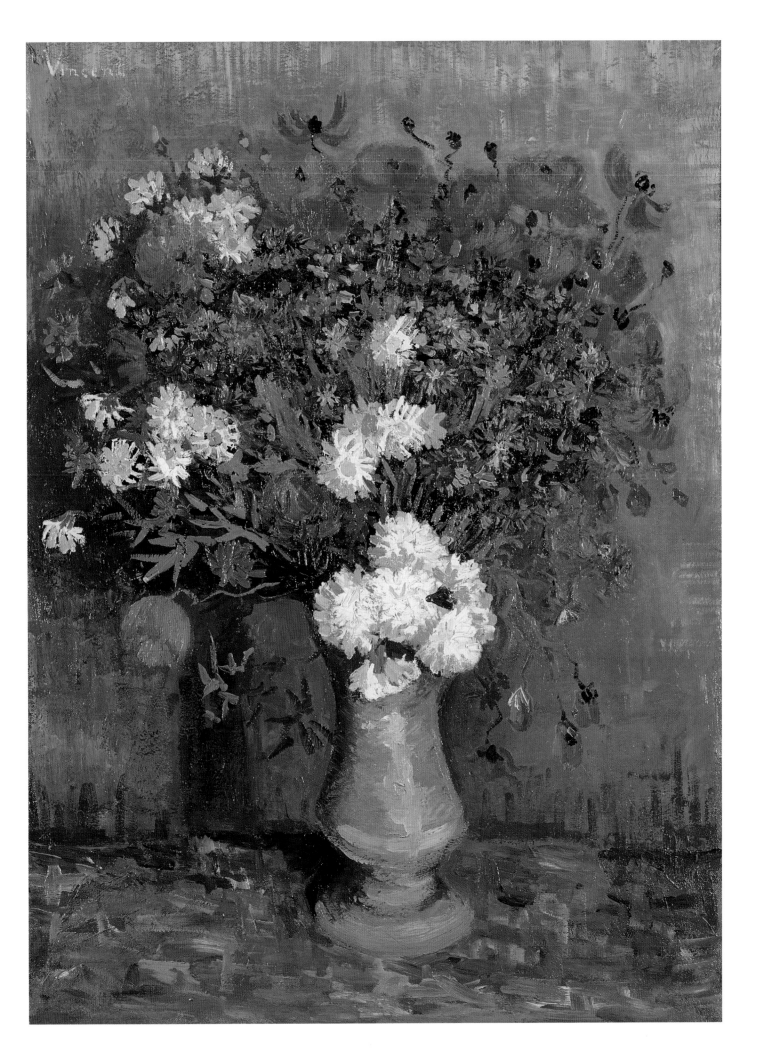

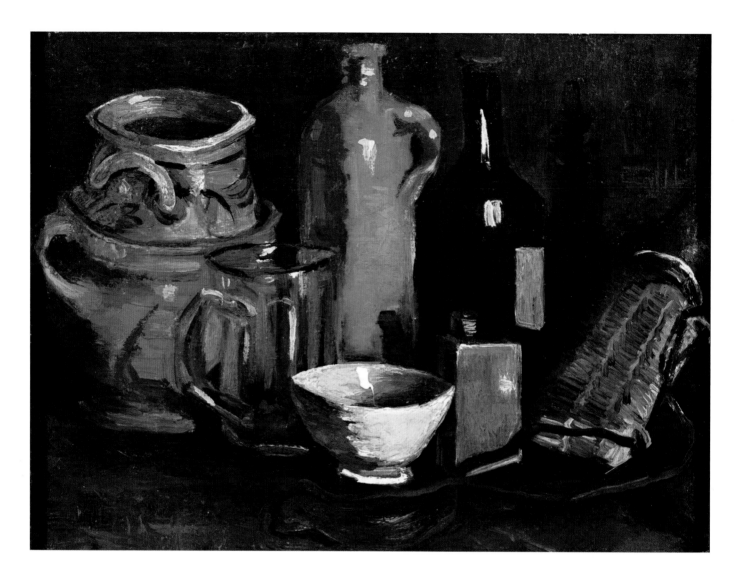

This is very similar to a classic still life from the era of the great Spanish still-life painters, such as Luis Meléndez. It has the general overall colour scheme of Meléndez and the dark background makes the massed objects loom out of the picture plane. It is a careful study, taking note of the materiality of the objects and placing them so that the repetition of their shapes produces a harmonious rhythm across the picture. Again one feels that Van Gogh was trying out everything he came into contact with in the artistic world. He was already painting with ease the effects of three-dimensional shapes in space and understood how to make tone work effectively for his compositions, but there is no hint of the explosion of light that was to take place in Provence. Here he is still in the shadows, so to speak, and still reliant on many other artists to help him along his path.

Still Life with Pots, Bottles and Flasks
Paris, 1886

A Pair of Old Boots
Arles, 1887

This composition was painted at the height of Van Gogh's colourful, expansive period in Arles. Although his handling of the textural quality of the paint has much in common with other works being produced at this time, the very close colour range is rather surprising. It is as if in the midst of his intense experience of contrasting colour effects, he has suddenly returned to the sort of work he was doing in Paris or even Nuenen. The picture is too light in tone for his earliest period, but he appears to have made a conscious attempt to reduce the handling of colour, perhaps for variety and to look again at tonal values.

Compare this work with the *Portrait of Patience Escalier* (p.97), done earlier the same month, with strongly contrasting colours that flare off the canvas. Here everything is muted and subtle, although the dark shadow on the right of the boots looks somewhat arbitrary in method. Perhaps they were Van Gogh's own boots, and symbolize him casting off a previous artistic embodiment.

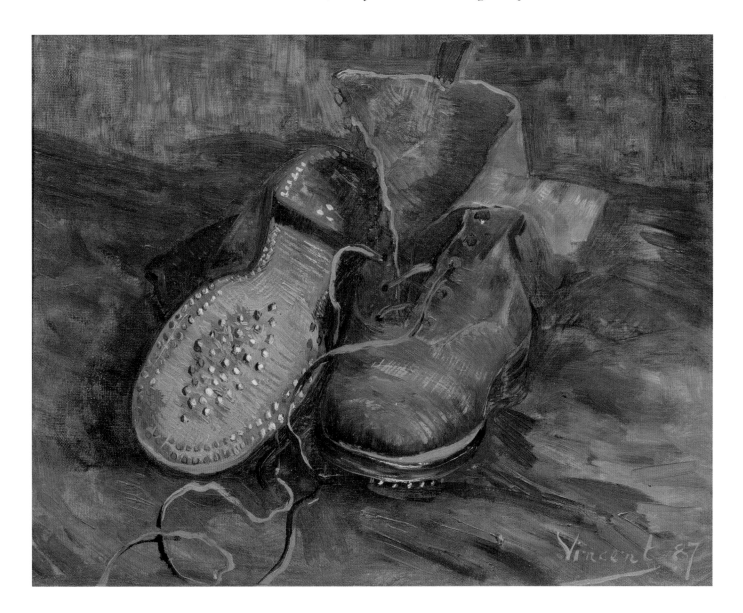

When Van Gogh painted this picture he was settling into the life of a painter in the Midi. To some extent it harks back to his Parisian way of painting, although it has evolved into a simpler, less technical method. The paint is thick and the drawing clearly defined, and there is a brightness about the colour that may not have been evident in a northern light. The composition is conventional, with the upright bottle dark against the pale background and the lemons scattered in and around the straw basket. The pale yellow of the table top makes the greener lemons look much darker. This work acts as a transition between *Still Life with a Basket of Potatoes* and the flower paintings of later in the year, having some of the latter's power and the more physical solidity of the earlier piece.

Basket of Lemons and Bottle
Arles, 1888

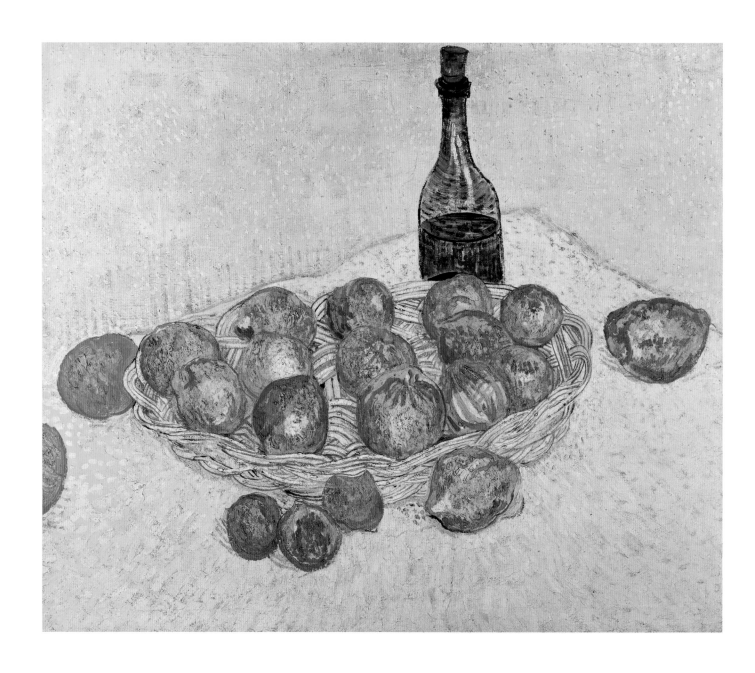

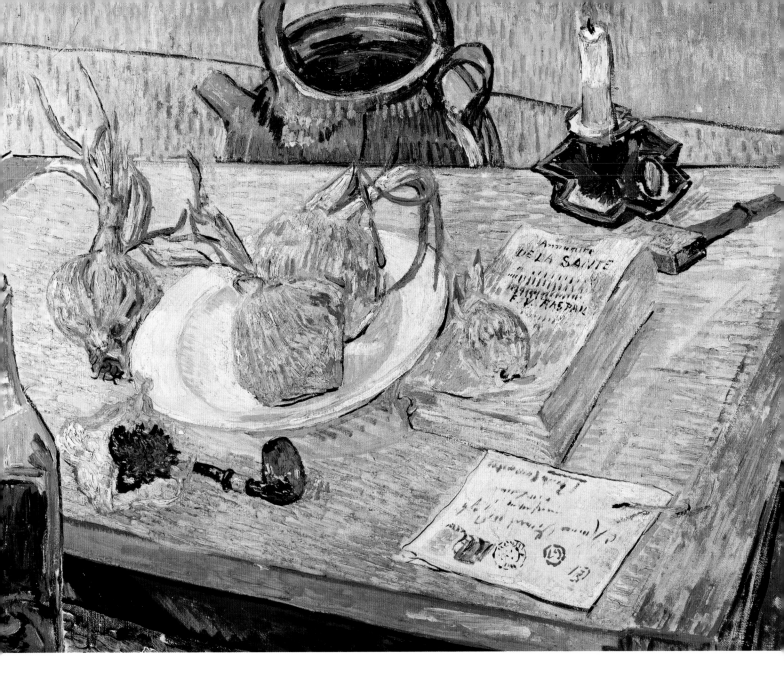

Painted in Arles, this relatively conventional still life has some similarity to the sort of still life Cézanne was also working on at this period. Van Gogh had probably met him in Paris and was now living not far from his home in Provence. The painting is in the classic mode of 19th-century French still-life genre and apart from the rather high viewpoint it is almost entirely traditional. The greatest difference from more typical still lifes of this period, which tells us that it is a Van Gogh, is the way that the yellow tablecloth shines out from the scene, flooding the picture with southern sun.

Van Gogh often placed himself firmly in the line of French painters who did not mind following the mainstream of artistic development, or even strove to do so. However, he also took up with great energy the role of revolutionary artist and created a new canon for future painters.

Still Life with Plate of Onions
Arles, 1889

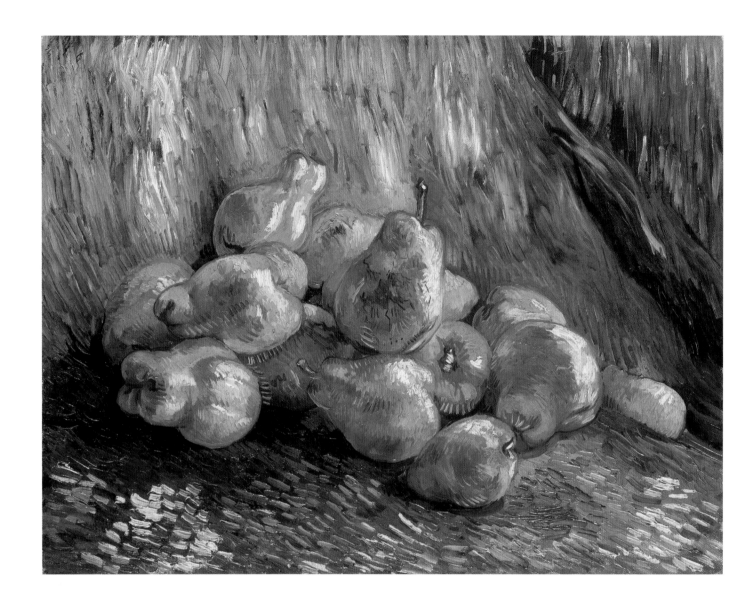

This still life of knobbly pears on a blue cloth shows the brilliance and solidity of Van Gogh's developing techniques of painting. By using complementary colours of dark yellow and smoke blue he produces an intense, striking painting. The foreground shadow and the sheen of the fabric are added in short, thick strokes of colour, giving a Impressionistic effect.

The way the light reflects across the rounded surfaces of the fruit tells of the dimensions and ripeness of the pears. Such heaped abundance seems to have been one of Van Gogh's delights when arranging a still-life composition.

Still Life with Quince Pears
Arles, 1888

Birds' Nests
Nuenen, 1885

This work was painted when Van Gogh was at Nuenen, most likely in the autumn of 1885. He had already proved his ability by painting the large masterwork *The Potato Eaters* (p.24). His skill was developing rapidly, although still in the traditional Dutch style, with dark backgrounds and a severely limited colour palette. This beautifully observed version – he painted and drew several – shows Van Gogh's understanding of light and his ability to use it to create the texture of the twigs, giving a convincing, tactile quality to the painting.

When Van Gogh moved to Paris in the spring of 1886 his palette began to brighten, ultimately resulting in the explosion of colour for which he is now famous. Towards the end of his life he said of this period, 'I sometimes regret that I did not simply stick to the Dutch palette with its grey tones.' Fortunately he only regretted it 'sometimes', as the world of modern art would have lacked a vital influence without Van Gogh's example of powerful colour contrasts.

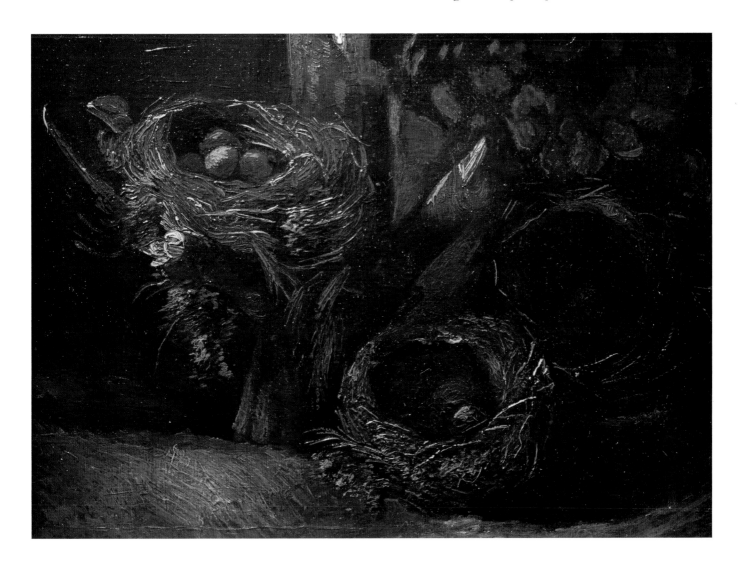

9

INTIMATIONS OF MORTALITY

During his last years, Van Gogh hinted at the probable shortness of his life. His letters describe constant battles with his illness and all the disturbing symptoms that accompanied it: depression, anxiety, dizziness, strange voices, difficulty in swallowing and agoraphobia. The emotional and physical exhaustion that he suffered must have made the idea of oblivion attractive by comparison: 'Often I said to myself that I preferred that there be nothing further, that this be the end.'

His use of certain motifs in his paintings, most notably the cast-off boots and the artist's empty chair, give a sense of his being disconnected, even from his most familiar possessions. Van Gogh was a confirmed loner in his last years; people recalled him trudging the roads with his painting equipment, but he would walk past without acknowledging them. Yet he complained to Theo of loneliness and having to sleep alone in the Yellow House.

During his year at St-Rémy, Van Gogh seemed to derive consolation from the protection of the asylum: 'I am not ready to leave here now or in the near future . . . it is only recently that my loathing of life has been drastically changed.' One picture from this period is *The Wheatfield Behind Saint-Paul Hospital with a Reaper* (p.126). Van Gogh described the figure as 'the image of death, in the sense that humanity might be the wheat he is reaping . . . But there's nothing sad in this death . . . with a sun flooding everything with a light of gold'.

By now, Van Gogh could not enjoy periods of good health for fear of his next attack: 'Even when my health has returned, I am still afraid.' In the early summer of 1890, he had but a short time to live. It was 'vast fields of wheat under troubled skies' that yielded his most significant intimations of mortality: *Wheatfield with Crows* (p.127) was his very own threshold to eternity.

This canvas of the church at Auvers-sur-Oise was painted in the summer months and Van Gogh has given the sky the deep ultramarine so evident in his paintings of the south. The church itself is a solid, towering set of blocks and pyramids with deep shadow in front and sunlit paths and grass in the foreground. A small female figure in country dress walks round towards the front of the church; the view depicted by Van Gogh is of the projecting apse at the east end. The heavy dark lines outlining the architecture help to give this painting strong graphic qualities without compromising the depth and substance of the building.

The Church at Auvers-sur-Oise
1890

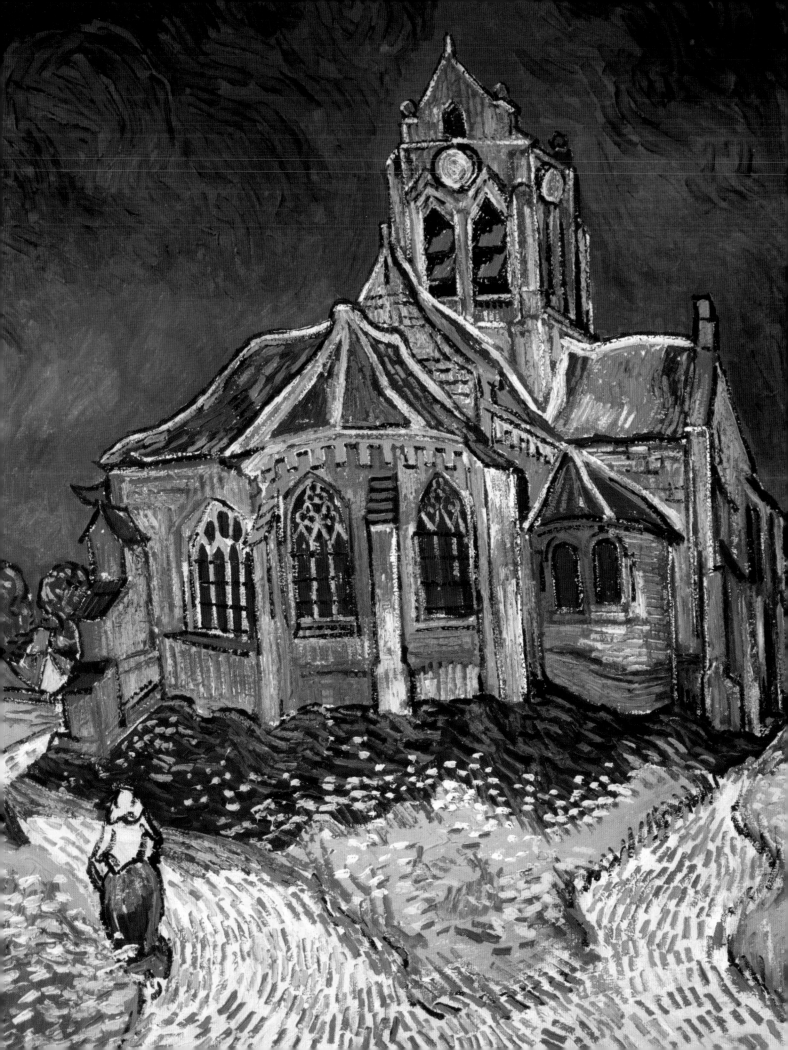

The theme of the sower was significant for Van Gogh, and probably began when he first copied Millet's *The Sower* in 1881. Millet was his early artistic hero and at one time Van Gogh said that a picture by Millet said more than most clergymen's sermons. He was most impressed by his work and considered him the greatest modern artist, even greater than Manet, of whom he thought highly for his attempts to produce new art.

This is one of the later variations that Van Gogh produced at Arles and the whole scene has a dramatic tension about it. The dark tones divide the canvas into bands, while the setting sun's rays suggest a halo near the sower's dark head, making the darker colours of the background look all the more ghostly. The view of the sower, which might be an optimistic one, looks baleful and rather sinister in this composition. Although Van Gogh describes the sower and wheatfields as symbols of infinity and certainty, the cycle of labour does not seem so hopeful. Here it is more akin to the sinister reaper symbol, which Van Gogh explained was symbolically opposite to the sower. This picture hints at Van Gogh's disappointment and exhaustion with the world.

Sower with a Setting Sun
Arles, 1888

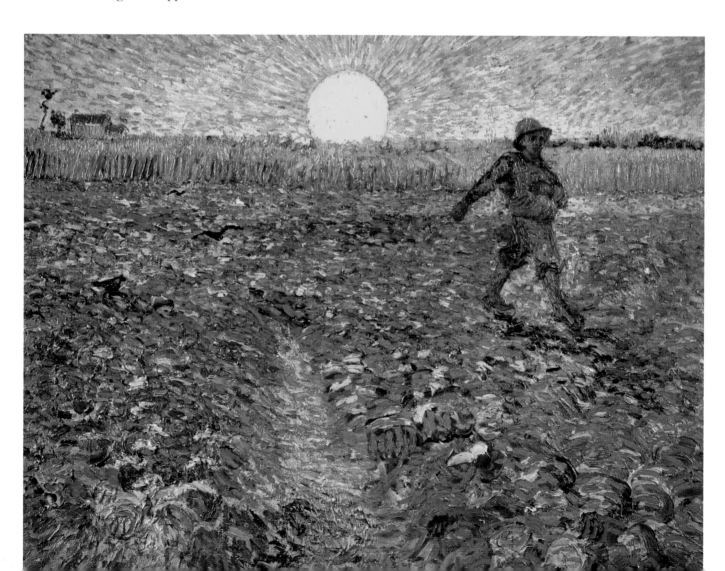

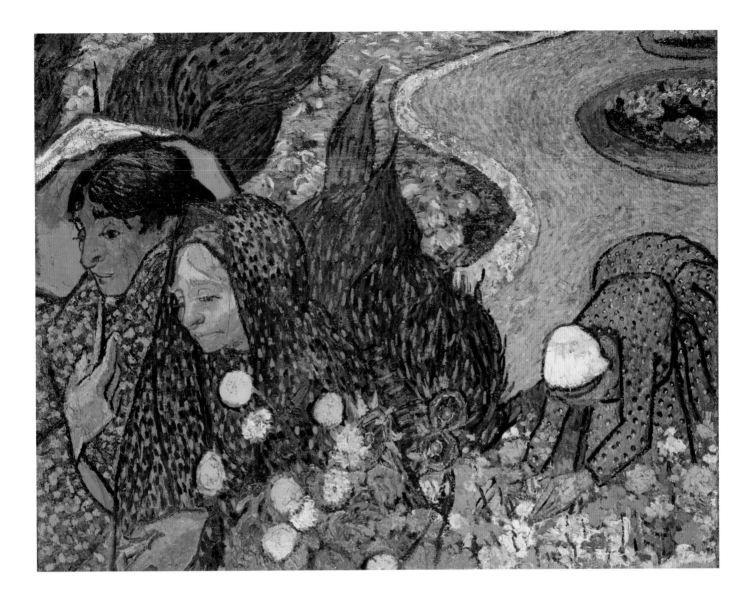

Memory of the Garden at Etten
Arles, 1888

'During my illness I saw again every room in the house at Zundert, every path, every plant in the garden, the views of the fields outside, the neighbours, the graveyard, the church, our kitchen garden at the back – down to the magpie's nest in a tall acacia in the graveyard. It's because I still have earlier recollections of those first days than any of the rest of you. There is no one left who remembers all this but Mother and me. I say no more about it, since I had better not try to go over all that passed through my head then.'

But Van Gogh did put it down in this painting. It is difficult to say with certainty who the people are; possibly one is his mother. The landscape is strangely patterned; the clothes and even the positions of the figures are depicted in a way that is difficult to understand. His childhood memories must have been like so many of our early recollections; oddly illumined snapshots of angles of places and people we cannot quite envisage. This may not be a rational piece of recollection on Van Gogh's part, but it is an intense visual memory of fragments of incidents melded together. It has the feeling of a melancholy picture as the faces of the two close-up figures look sorrowful.

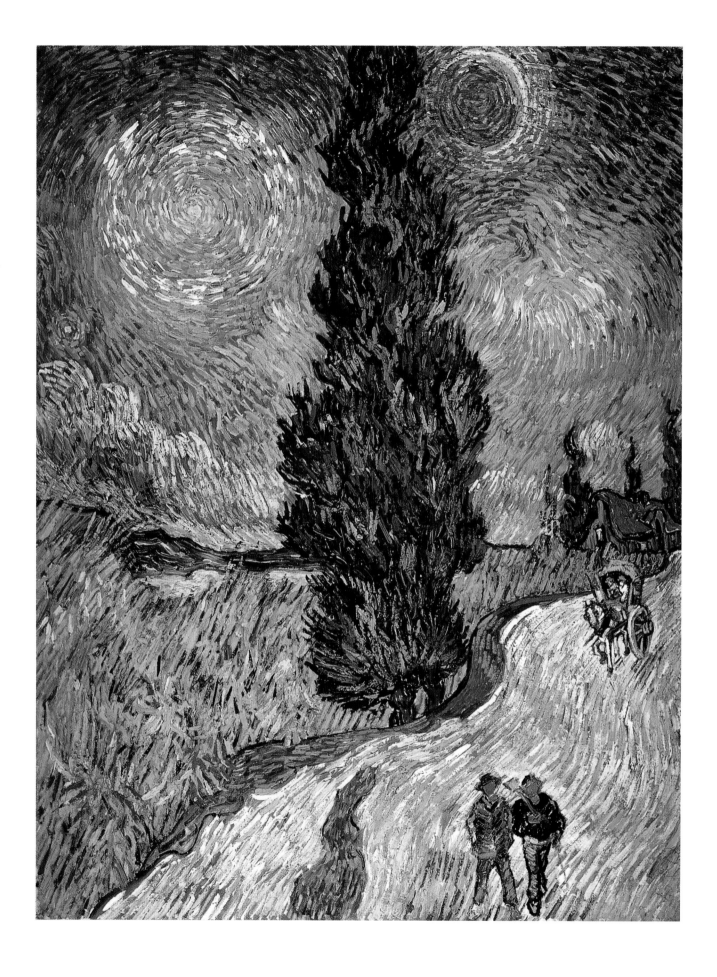

Country Road in Provence by Night
St-Rémy, 1890

In this powerful painting, Van Gogh combined several of his favourite images. As he said eight years previously: 'There is something infinite in painting – I cannot explain it to you so well – but it was so delightful just for expressing one's feeling. There are hidden harmonies or contrasts in colours which involuntarily combine to work together and which could not possibly be used in another way.'

It is marvellous that his desire to paint cypress trees, those 'Egyptian obelisks' of nature, his vision of the luminous star and moon, and underneath it all the swirling, writhing road and the cornfield have been brought together in this work. Van Gogh seems to have drawn on all his memories of previous images and created a combined icon of natural power. The colours, as he said, 'involuntarily combine to work together' as if in a visionary power, out of a dream. It is the natural result of his earlier words: 'I know for sure I have an instinct for colour, and that it will come to me more and more, that painting is in the very marrow of my bones . . . I feel such creative power in myself that I know for sure that the time will arrive when, so to speak, I shall regularly make something good every day.' And of course so he did, in these last two years of his life, excepting only when he was too ill to work. This swirling, intense piece of painting was produced while he was undergoing a form of convalescence at St-Rémy: creative power indeed.

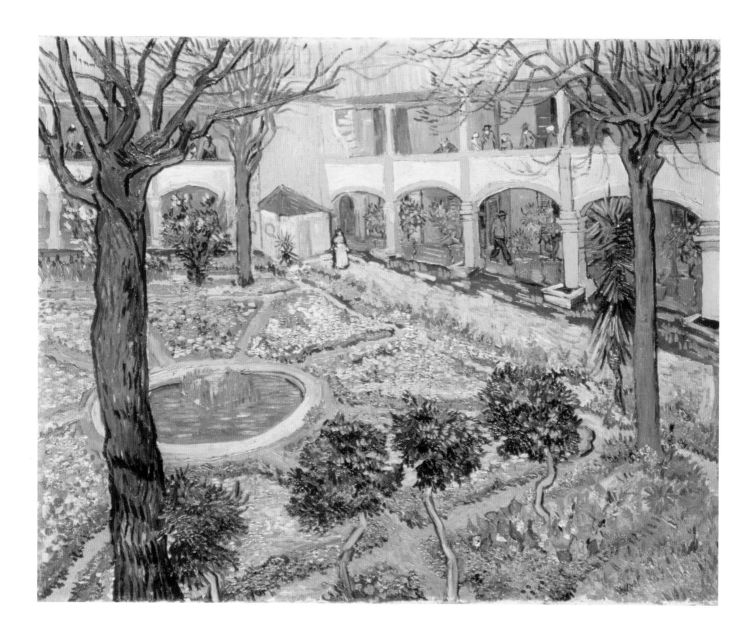

This is a spacious view of the asylum gardens where Van Gogh was treated after his break with Gauguin and the episode of the cut ear. The gardens look delightful – colourful and full of light. Although painted in winter, this is an optimistic picture, especially as the high viewpoint gives us a wide vista of architecture and grounds. There is no hint of the mental disturbance that Van Gogh was suffering at the time. He is still able to create a positive view of the world – a triumph of artistic genius over very difficult circumstances.

This picture shows Van Gogh's mastery of drawing outside from life. The solidity and ruggedness of the tree trunks, the beautiful ellipses of the stone pond and the perspective of the hospital buildings make this a masterpiece of technique. His careful handling of tone not only gives the effect of light and shade, but also of the materiality of the different aspects of the picture.

Garden of the Hospital at Arles
1889

Enclosed Field with Rising Sun
St-Rémy, 1889

This is another extraordinarily vivid and hopeful looking landscape, as seen from the windows of Van Gogh's hospital room at St-Rémy. The red-blue stone walls throw into relief the vivid green, lush field; the blue distant hills are quiet and orderly; and above all the vibrant golden sun bounces back the daylight which must have flooded straight into Van Gogh's face as he painted this picture. It can be seen as symbolic: the unmown meadow of grass is springing with life, but enclosed within walls representing those of the asylum, while outside is a well ordered and calm landscape under a bright rising sun. It is an optimistic view, perhaps, of his own condition at the time, and the world he hoped to return to outside the asylum.

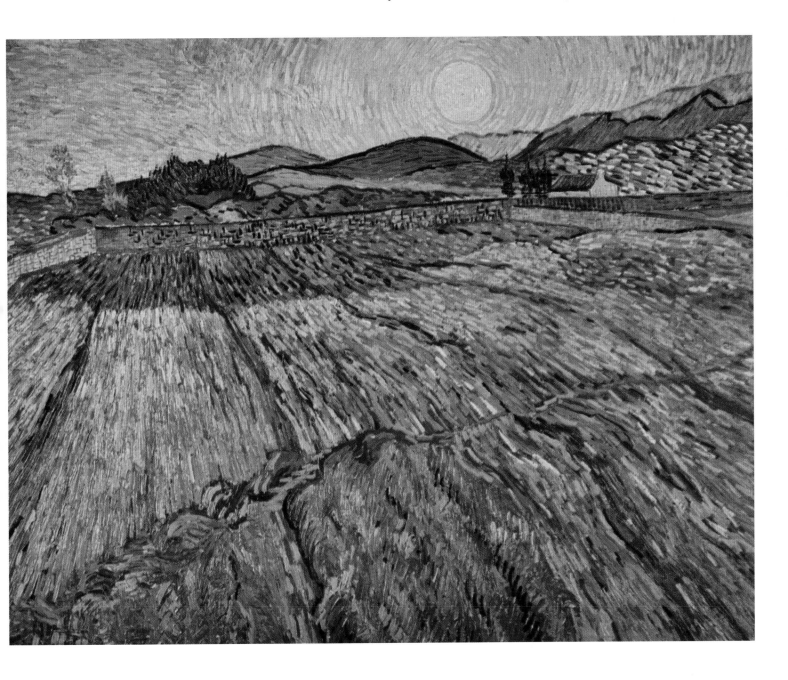

This image is the symbolic opposite of Van Gogh's picture of the sower (p.120). Here the reaper works across the sun-drenched field, stacking the wheat under a burning sun and sky. Van Gogh wrote, 'I am struggling with a canvas begun some days before my indisposition, a 'Reaper'; the study is all yellow, terribly thickly painted but the subject was fine and simple. For I see in this reaper – a vague figure fighting like the devil in the midst of the heat to get to the end of his task – I see in him the image of death, in the sense that humanity might be the wheat he is reaping. So it is – if you like – the opposite of that sower I tried to do before. But there's nothing sad in this death, it goes its way in broad daylight with a sun flooding everything with a light of gold.'

The Wheatfield Behind Saint-Paul Hospital with a Reaper
St-Rémy, 1889

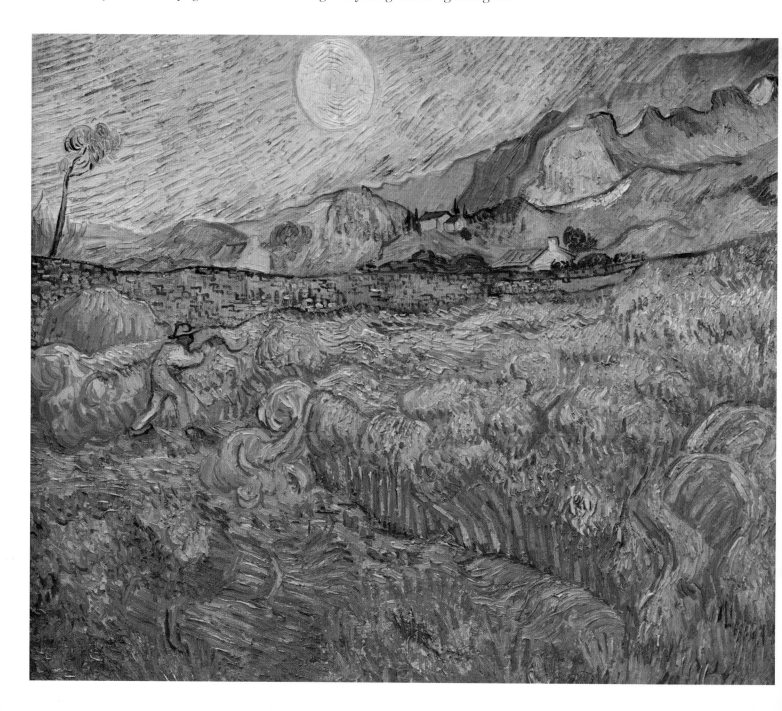

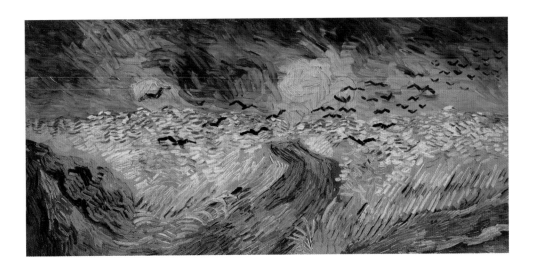

Wheatfield with Crows
Auvers-sur-Oise, 1890

'What am I in most people's eyes? A nonentity, or an eccentric and disagreeable man – somebody who has no position in society and never will have, in short, the lowest of the low. Very well, even if this were true, then I should want my work to show what is in the heart of such an eccentric, of such a nobody.' This is what Van Gogh said in 1882, eight years before he painted the wheatfield seen here, considered by many to be the last painting he did before he shot himself. 'This is my ambition, which is, in spite of everything, founded less on anger than on love, more on serenity than passion. It is true that I am often in the greatest misery, but still there is a calm pure harmony and music inside me.'

This dynamic and rather disturbing picture helps to sum up the effect of Van Gogh's painting on the art-loving world. Its vigour, drama and composition are all of the greatest power and its colour contrasts are like a direct statement of his perceptiveness and intense connection with the natural world. Few of Van Gogh's contemporaries appreciated the beauty he created in his lifetime, but now the whole world places an enormous price on all his canvases, a price which would have kept him and his family for life.

It is thought that Van Gogh foresaw his own suicide in the symbolically ominous sky and the flapping black crows, but maybe we read too much into it. He may indeed have planned to kill himself before he actually attempted it, but his final letter to Theo, in which he ordered new paints, suggests that he planned more painting, not death. In the letter, found in his pocket after he died, he wrote, 'Ah well, I risk my life for my own work and my reason has half foundered in it – very well – but you're not one of the dealers in men; as far as I know and can judge I think you really act with humanity, but what can you do.'

Reproduced with the kind permission of Art Archive Picture Library: 41, 43, 47, 58, 74, 82, 89, 104, 119

Reproduced with the kind permission of AKG Picture Library: 22, 29, 45, 78, 87, 103, 113, 114, 115, 116, 117, 126

Reproduced with the kind permission of the Boijmans van Beuningan Museum: 20

Reproduced with the kind permission of the Bridgeman Art Library: 17, 23, 27, 30, 32, 35, 36, 42, 52, 53, 54, 59, 64, 65, 73, 75, 82, 83, 85, 97, 111, 112, 124

Reproduced with the kind permission of Corbis Picture Library: 24, 40, 44, 51, 56, 60, 79, 92, 98

Reproduced with the kind permission of the Coll. Kröller-Müller Museum, Otterlo: 19

Reproduced with the kind permission of RA/Lebrecht Music & Arts: 69

Reproduced with the kind permission of Interfoto/Lebrecht Music & Arts: 84

Reproduced with the kind permission of Van Gogh Museum Amsterdam (Vincent Van Gogh Foundation), loan from private collection: 18, 100

ACKNOWLEDGMENTS